PARASTOU FOROUHAR

Art, Life and Death in Iran

ISBN: 978-0-86356-448-2

First published by Saqi Books in 2010
Copyright © All images, Parastou Forouhar, 2010
Copyright © All text, the authors, 2010

A full CIP record for this book is available from the British Library
A full CIP record for this book is available from the Library of Congress

Manufactured in Lebanon

SAQI
26 Westbourne Grove, London W2 5RH, UK
2398 Doswell Avenue, Saint Paul, Minnesota, 55108 USA
www.saqibooks.com

Beyond Art PRODUCTIONS with the support of **ROSE ISSA PROJECTS**

269 Kensington High Street, London W8 6NA (www.roseissa.com)

Design: normal industries
Copy: Katia Hadidian
Production: Francesca Ricci

Front cover: "Friday", digital photographic print, 6m x 2m (2003)
Back cover: "The Funeral", installation of office chairs and fabric (2006)

PARASTOU FOROUHAR

Art, Life and Death in Iran

Edited by Rose Issa

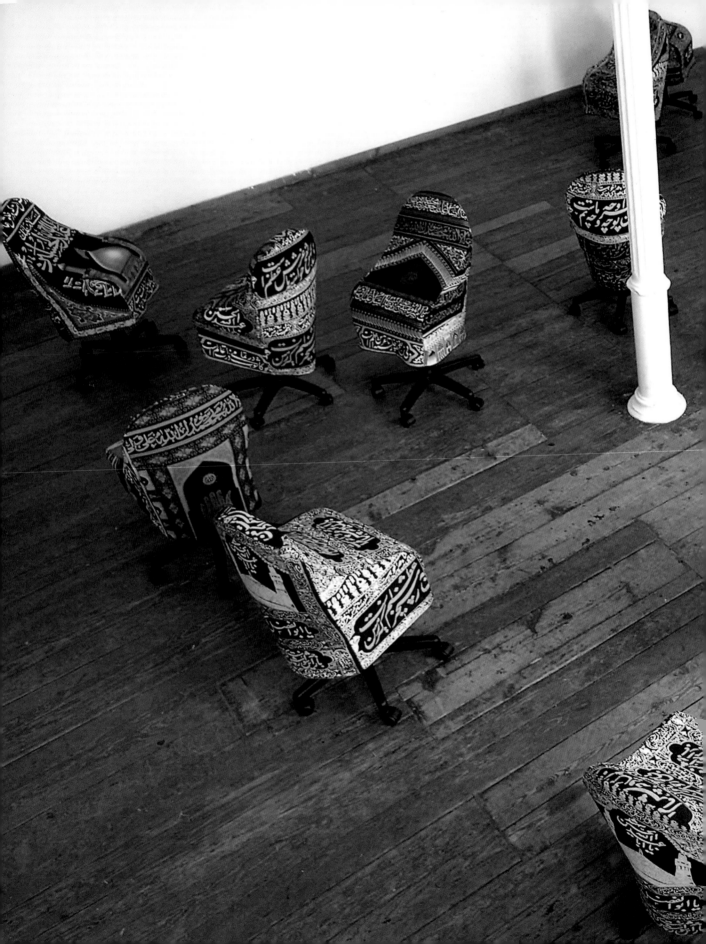

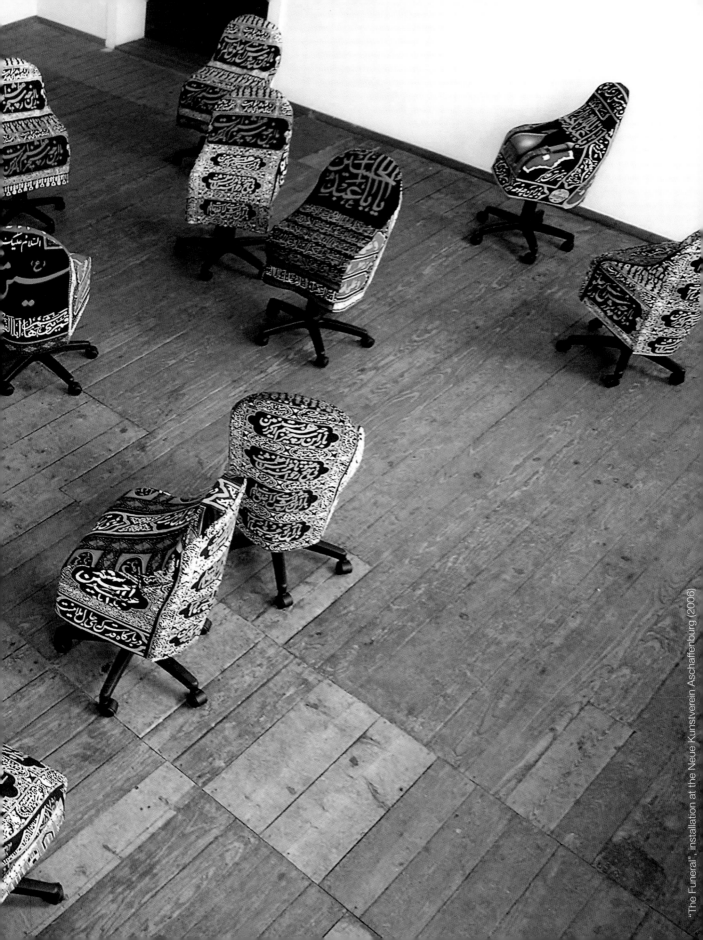

FOREWORD

I first discovered Parastou Forouhar's work in 2003 at one of my favourite museums in Berlin – the National Gallery Hamburger Banhof – which has wonderful Joseph Beuys and Anselm Kiefer collections among other well-chosen international artists.

I was taken by surprise by a most bewildering solo show, Forouhar's "Tausendundein Tag" ("A Thousand and One Days"). The exhibition featured a large and very colourful installation, "The Funeral", of 22 office chairs. The artist later told me that these symbolise two dramatic events: the date of the Iranian Revolution on the 22nd of the month of Bahman, 1979 (11th February in the Western calendar), and also the 22nd of November 1998, when both her parents died. There were also some intriguing photographs and marvellous digital drawings on textile and wallpaper, whose interwoven patterns resembled Escher's drawings. Only on close inspection did I see that the patterns were in fact images of instruments of torture and human bodies being pulled apart or hung with black ropes. The exhibition also included an interactive documentation about the tragedy that changed her life – the savage murder of her parents in Tehran –

and an animation film about her search for these killers in the corridors of bureaucracy. It was spellbinding, dramatic, tragic and also, in terms of aesthetics, wonderfully expressed.

Of course this body of work could only come out of urgency, to exorcise her grief the only way she knew: through art. Parastou Forouhar's parents, Dariush and Parvaneh Forouhar, were intellectuals and activists, supporters of the democratically elected and popular Prime Minister Mohammad Mossadegh (who was overthrown in 1953 in a coup masterminded by the CIA). They were also critical of the Shah, who imprisoned them several times. After the Revolution, Dariush Forouhar served as Minister for Labour under Mehdi Bazargan, who was Prime Minister from February to November 1979. Forouhar was a scholarly man respected for his honesty and decency, and was obliged to resign as a believer in securalism and women's rights, and not the theocratic state that Iran became after the Revolution. For many, the new religious government seemed medieval in its jurisprudence, feudal in its tenets, and patriarchal in the very fabric of its being.

Right away I decided to feature Forouhar in "Far Near Distance", a group show that I was preparing for the House of World Cultures (Haus der Kulturen der Welt) in Berlin in 2004, for which she prepared an installation. At the time, my research was mostly on Iranian artists from within Iran, while Forouhar – like many artists of her generation – had to settle abroad. However, the colour, humour and playfulness in her wonderfully powerful work have that rare combination of serious German pedagogical training with a deep understanding of her Iranian culture and background.

I discovered on working with her that she is one of the most articulate artists I have ever encountered, having inherited her parents' spirit of rebelliousness and love of precise words. To this she has added her personal sense of humour, transforming tragedies into black comedies, visualising serious matters with warmth and wit – fantastically exceptional qualities.

Forouhar is a traveller who despite having only an Iranian passport – with all the bureaucratic difficulties that entails – nevertheless manages to create site-specific works in many different places. She is also a loving daughter who continues her parents' legacy, to keep their memory alive. She is a mother who protects and supports her sons, and a generous human being whose sense of justice runs deep in her veins but with humour and no cynicism.

Her work is more than engaged – it initiates public discourse. She has inherited a family tradition – the quest for justice – and has translated that into new aesthetic vocabulary. The woman and the artist have an impressive resilience and resistance to obstacles. Her creativity expands into many spheres, and she is currently writing her biography.

The catalogues for many of Forouhar's outstanding, landmark exhibitions are in German, as are many of the articles about her, so I decided upon this modest introduction to her work. It pays homage to her creative genius; to the Hamburger Banhof – to which I remain eternally grateful for that first glimpse into her world; and to Leighton House Museum, which generously enabled me to bring her work to London.

Rose Issa, London 2010

"When I arrived in Germany, I was Parastou Forouhar. Somehow, over the years, I have become 'Iranian'."

"This enforced ethnic identification took a new turn with the assassination of my parents in their home in Tehran. My efforts to investigate this crime had a great impact on my personal and artistic sensibilities. Political correctness and democratic coexistence lost their meaning in my daily life. As a result, I have tried to distill this conflict of displacement and transfer of meaning, turning it into a source of creativity."

Parastou Forouhar

A CULTURAL PREDICAMENT

My first contact with Parastou Forouhar and her "automatic recognition of the unfamiliar" was when I saw "The Swanrider" on the back cover of *Iranian Photography Now* (Hatje Cantz, 2008). This amazingly graceful photograph (see pages 108-109), so full of charm, wit and multi-dimensional irony, is simply stunning – as an image, statement, wish and window into the artist's empathies. The placid figure of The Swanrider paradoxically screams from the printed surface, and in a succinct, restrained way echoes slogans of shared humanity and common dreams. She typifies the depiction of what Dr Martin Barnes so elegantly and euphemistically describes in his preface to the book: "individuals grappling with the state of a country where tradition and modernity face each other". This elegantly gliding image embodies the "urgent quality" that the Iranian art historian Parisa Damandan finds lacking in Western photography.

Often, if one delves into the lives of Iranian women artists there is a trauma or experience that sets off a sort of "artistic tinnitus". Inured as we might think Iranian artists are to the prevalence of blood and death in Iranian culture and imagery, the real thing – the death of a close family member – is obviously a void in the artist's life that somehow feeds her creativity. In the output of an Iranian woman artist from a different generation, such as Monir Shahroudy Farmanfarmaian, the loss of her husband Abol (even at a respectable age) unleashed a memorable series of expressions of mourning, rendered in repetitive shapes and patterns.

Forouhar's loss is tragic, and unexpected if not unforeseeable. The voices of her parents, opposition politicians in Iran who were brutally murdered at home in Tehran in 1998, continue to be heard through their daughter's work. "Documentation, 2003" makes this blatantly clear. In this installation at her "A Thousand and One Days" exhibition at the Hamburger Banhof, we see more about the death of one's parents than a human being should have to know. The German art critic Annette Tietenberg says that Forouhar "always stands on the side of those who engage themselves for the respect of the rights of man, the ostracism of tyranny, and the strengthening of civilian society" (*Nafas Art Magazine*, April 2003). In essence, she is realising

Professor Homi Bhabha's warning in the foreword to *Iranian Photography Now* about "the dangerous slide of dogmatic truth into political tyranny".

In her compelling book, *Portrait Photographs from Isfahan: Faces in Transition 1920-1950* (Saqi Books, 2004), Parisa Damandan touches on the creative urge behind some of the greatest Iranian art. In a sentence that can be read as a historical and contemporary comment: "One has the intuitive impression that much of the work... is created by photographers... goaded by oppressive forces outside their control [who] are compelled to short-circuit to the emotive heart of an issue." As the American folklorist and musicologist Alan Lomax said, "If we continue to allow the erosion of our cultural forms, soon there will be no place to visit and no place to truly call home."

Forouhar draws on a large reservoir of Iranian cultural forms and uses them to create pieces with great lyrical content, even when their message is abrupt, blunt or simply full of foreboding. She goes straight to the emotive heart of the issue: various pieces exhibit

unremitting pain, yet her pain is cloaked in nostalgia, in echoes of good times, in divinely beautiful curves, in poetry written over the floors and walls, and a feminine elegance. There is obviously anger in her output, too, as "Friday" shows (pp. 100-101). By using the chador in photographs and her pictogram "Signs" (pp. 92-95), she hints at a subtle form of sexual domination. Alexandra Karentzos, Professor of Post-Colonial and Gender Studies at the University of Trier, notes that: "The space allocated to the women in the signs is extremely restricted – they have less space than the men – and is defined by a red line, which forms, as it were, a double boundary." The "Signs", like much of Forouhar's work, have a reductive simplicity that brands its multi-dimensional message directly onto our brain. As Karentzos points out, the signs are a cliché upon a cliché, and one can imagine them not raising any eyebrows from Iran's religious establishment.

The genesis of these pictograms may date from Forouhar's experience at the Tehran Academy of Arts in 1984 when, having been closed for two years during the Iranian "cultural revolution", institutions

of higher learning reopened with ostentatiously strict religious demands made on the staff and students. "The new social system of order consisted of strong religious rules that regulated public life in its smallest detail," Forouhar remembers. The small space allotted to the woman in these pictograms reflects beautifully the segregation of men and women at the Academy. The male figure even bears some of the "anti-elegance" that was so fashionable at the time.

The pictograms also hint at what Forouhar has referred to as her "forced ethnic identification" – the disturbing reality forced upon her by whoever ordered the murder of her parents, thus dragging her back from being a cosmopolitan or simply an artist with an Iranian name. The domestic execution of her parents also put an end to her extra-territorial identity and forever stamped part of her artistic personality as a victim of the Iranian regime. The anger at being vacuumed into a world she had left is palpable in her later output.

The logistics of functioning as an artist in Iran, or as an Iranian expatriate with an enforced identify, might appear impenetrable, arcane, arbitrary and stifling. Perhaps all these are true interpretations of an Iranian artist's physical and mental restrictions, but in photography, as with painting and sculpture, many works produced in the 30 years since the Revolution echo with latent sensuality, exquisite sensitivity and communicative fervour. We might also ask whether Forouhar wanted to be an "Iranian" artist; whether her vision was once free to roam and use her new country, Germany, as the source of her inspiration. Is Iranian culture too strong – the years studying Hafez, Saadi and Rumi; the attractiveness, beauty and inescapability of Iran's written and visual language – for an artist to set it all aside and then live with the paradox of always being seen as an Iranian expatriate or, as the artist herself says, simply as "Parastou Forouhar"?

The shapes of her bean-bag chairs in the installation "Countdown" (pp. 36-37) are like chadored women waiting to be sat upon; the "Red Cyclist" (pp. 118-119) might be naked underneath; the lumpen female outline in one road sign kneels in trance-like humiliation to the man above her (p. 95); and the blank back of a man's head in "Blind Spot" (pp. 102-103) and the hand peering out from the black chador in "Friday" are perhaps the most blatant reductions of Iranian women into no more than an inviting face and pudenda. They may also be a trenchant critique of the schizophrenic new rules of the Tehran Academy, where Forouhour remembers the images of male and female nudes in library books being painted over in black ink.

Hinting at this official dyslexic form of teaching, Forouhar's fabric designs in the series "Eslimi" (pp. 92-97) reveal repeated images of genitals intermingled with various household tools that could be used as instruments of torture on soft fleshy parts of the body. These are overlaid with reductive outlines of women in poses of abject self-denigration and a co-mingling of sexuality and implied pain. By turning violence, humiliation, trembling figures and genital motifs into a book of fabric patterns, to be flicked through like a home-furnishing catalogue, Forouhar makes a strong statement about harsh religious interpretations infiltrating the most banal and quotidian aspects of life. Dissident to its last fibre, the "Eslimi" series questions the legitimacy of an authoritarian government under whose rule "anyone who questions its authority, or is even indifferent to it, can be regarded as a threat", as Malu Halasa and Maziar Bahari comment in "*Transit Tehran: Young Iran and Its Inspiration*" (Garnet Publishing, 2008).

One of the most startling aspects of the artist's output is the overwhelming femininity that oozes from her fabric-covered furniture and repeated motif designs, so reminiscent of Soviet utopian patterns. But her

work also has a palpable rage, expressed with embroidery-like precision; measured, calculated and never straying into that male area of redemption through destruction.

Rose Issa often speaks of post-revolutionary Iranian society being almost hermetically sealed and of the agility and cleverness of Iranian artists in finding "loopholes" in the restrictions imposed on their output. In resorting to dissimulation, contemporary Iranian artists inside and outside Iran exploit a concept with a respected pedigree in many Shi'ite societies. It grants the artist, paradoxically, a parallel reality where nothing is necessarily as it seems and where they find a refuge for their exquisitely refined coded expressions. Forouhar is not optimistic about the longevity of these small spaces, as she told Werner Bloch in the online magazine, *Qantara.de* (July 2009): "Before him [Ahmedinejad], there were spaces for freedom and creativity... All this has been suppressed little by little."

In an interview for Deutsche Bank Art Magazine with Brigitte Werneburg, Forouhar said of her 2002 show, "Schühe ausziehen" ("Take Off Your Shoes", pp. 84-85): "At the moment... I'm more involved with politics than with art. To make art you need time to reflect, and the events of the moment are so urgent that the main thing for me is to follow them and take them in."

Fortunately, the artist's dissimulation has opened an easily accessible path to understanding the emotional, personal and political helter-skelter around the issues of identity, dislocation, gender and volcanic anger. To paraphrase the title of one of her own works, we can see in her output that of an "unfreiwillige Heimatskünstlerin" or "involuntary homeland artist".

Russell Harris, London 2010
Russell Harris is an author, curator and art critic

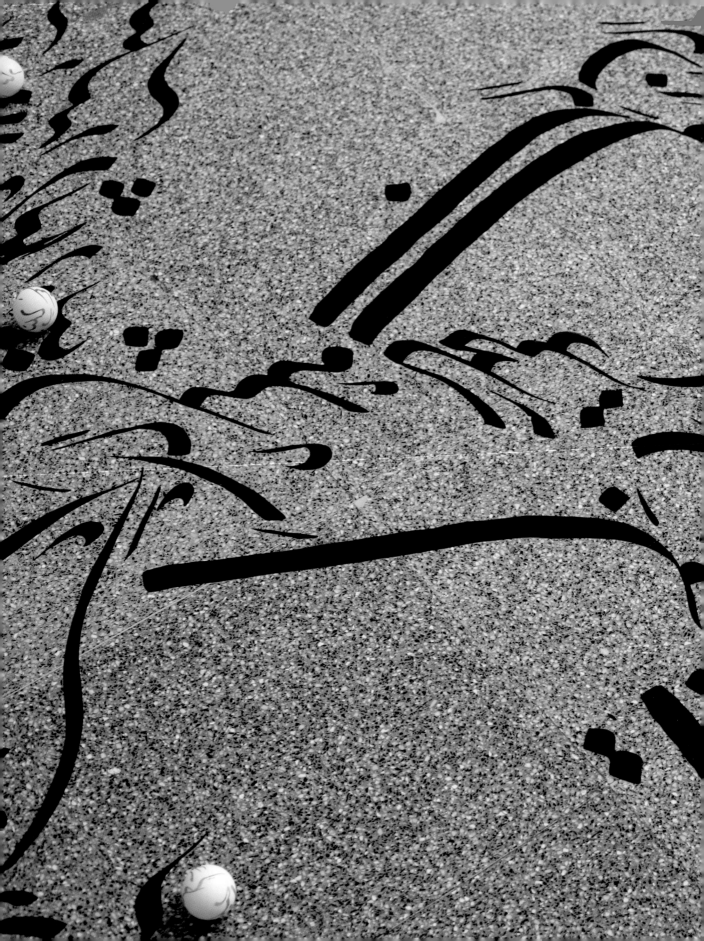

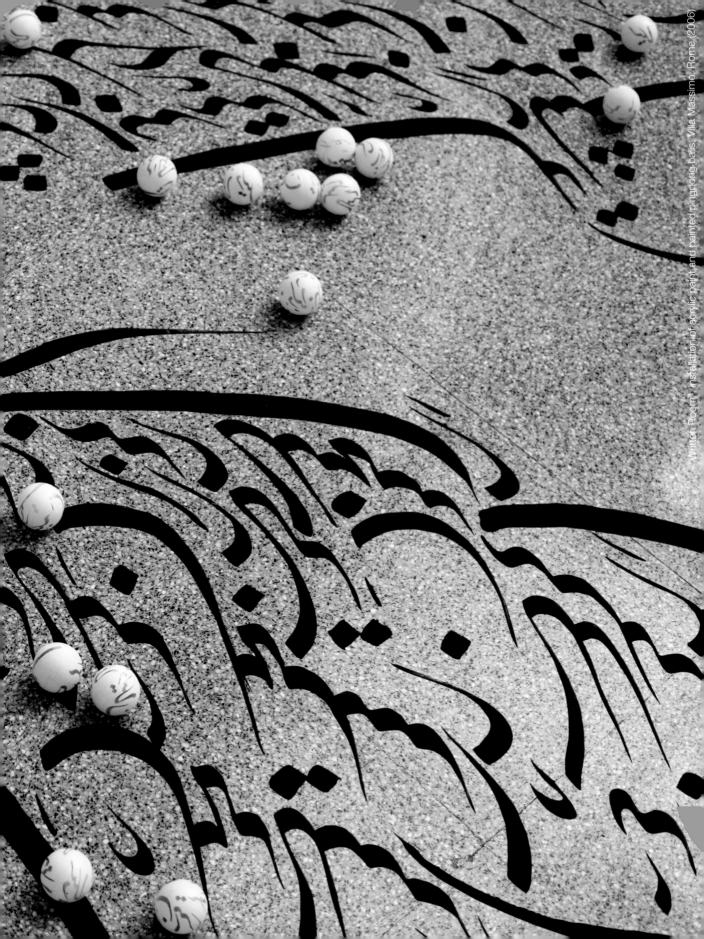

ART, DEATH AND LANGUAGE

Parastou Forouhar was raised and educated in Tehran. She was seventeen when the Islamic Revolution began. Her parents, Dariush and Parvaneh Forouhar, were both well-known intellectuals and opposition politicians engaged in the struggle to keep the established separation of State and Religion in place. During her student days at the University of Tehran, the young artist was exposed to the restrictive measures of the theocratic government's new curicculum. Early experiences of private and public terror have formed her life and artistic outlook.

Since 1991 she has lived in Germany. After the horrendous assassination of her parents in 1998 by secret agents of the regime, the artist decided to become politically active. She included documentation regarding the murder of her parents and her struggle to uncover and bring to justice the perpetrators of that crime in her 2003 exhibition in Berlin, "Tausendundein Tag" ("A Thousand and One Days").

Forouhar's family background and experience as a woman in Iran and an exile in Germany have formed and solidified her thinking and political engagement.

Her activism for human rights and justice expresses her belief in the possibility of change. Her response to the horrors of our times gives her work purpose and energy, living in Germany has made her aware of the burden of memory prevalent in that society for crimes committed during the Nazi period. Seeing historical and psychological parallels with the Iranian trauma, she invests her art with a sense of personal responsibility that clearly implies a collective dimension. The American cultural critic Rebecca Solnit once defined this kind of position aptly: "Apolitical art and artless politics are the fruit of a divide-and-conquer strategy that weakens both, art and politics ignite each other and need each other."[1]

Forouhar has studied classical Persian art. With her profound knowledge of the history of ornament and the technique of calligraphy, the artist connects the work of the great masters of Persian miniature painting with a contemporary criticism of the "ornament of the masses", which she sees as a uniformity imposed by the tyrannical power of Mosque and State. She has come to distrust ornament as a "harmonising" system and sees in it instead a metaphor for anti-individualistic

tendencies. In a lecture on "Fundamentalism and Art" in 2002, the artist discussed the use of ornament and lettering in Islamic culture: "All surfaces are covered with the vibrations of patterns. They represent the harmony of the world, of God's all-embracing power and beauty ... But this untouchable harmony can only be appreciated from a distance, as it conceals a great potential for brutality. All that does not submit to this strict canon of ornamental order cannot be represented and is therefore non-existent; it is expelled into the periphery of the un-worthy and is condemned to extinction."

This principle of cultural and social exclusion reflects the drama of the individual in opposition to the oppressive conditions in present-day Iran. It reflects too on the artist's status as an outsider. Forouhar suggests that, "Life in the world of the old Persian miniatures is unbearable. People are allocated their place, given their body posture, their specific colour, so that their presence amplifies the ornamental order. With great effort I have escaped this role and I refuse to be dragged back into a similar condition, into the suffocating world of pre-set patterns."[2]

Every year the artist visits Tehran to commemorate the death of her parents, a journey marked by the installation "Trauerfeier" ("The Funeral") of 2007 (see pages 4-5 and 34-35). In this work she covers office chairs with a garish, mass-produced cloth sold in Tehran's markets for Ashura, the annual Shi'ite ceremony that mourns the martyrdom of Imam Hossein in 680. Following tradition, the material is marked with calligraphic signs spreading across the entire surface. The repetitive writing of words and verses transmit their ancient authority like a rhythmic chant. Originally these printed shrouds came in symbolic, plain colours – black and white, red and green – but over the last twenty years there has been a drastic shift in style. The cloth is now printed in day-glo colours, indicating a degree of vulgarisation but also an interesting mixture of religious temperament with pop culture. Images of minarets, holy places, the names of the martyred family of the Prophet, and the hand of Fatima appear in the spaces between the floating letters, popularising the institutionalised power of the Mosque. "The Funeral" is about absence and inspires identification with the victims.

[1] Interview by Peter Terzian with Rebecca Solnit in the *Columbia Journalism Review* (July/August 2007)
[2, 3] From Parastou Forouhar's lecture, "Mit Schleier-ohne Schleier"

("With Veil, Without Veils"), at the conference, "Fundamentalism und Kunst" ("Fundamentalism and Art"), 17 March 2002, at the Museum Kunstpalast, Düsseldorf

Forouhar's realisation of the darker meaning of Persian ornamentation has of course not undermined her love of its beauty and dignity. To her, the richness and variability of traditional patterns continue to represent visual proof of eternity: "I am Persian. I can tell you beautiful stories about my homeland, which may not be true. I have wonderful memories of my country, but I do not know if I have manipulated them. At some point, a time whose precise date I cannot remember, I started re-building the idea of my homeland into a fortress of illusions. Ever since, it has grown in my mind invisibly and beautifully. I search for my home-land by writing words of my mother tongue in soft, rhythmical, inviting lines, remembering the openness and ambivalence of the beautiful Persian patterns that the old masters of past centuries have left to us."[3]

Starting in 1999 with her installation "Heimat Anschrift" ("Home Address"), Forouhar has created a number of site-specific works in which she covers entire rooms with cascades of calligraphy. Various degrees of density generate patterns of different expressiveness. Writing in the "Shekasteh" calligraphical style, she repeats memories, names and fragments of words. Foreign and unreadable to Western audiences, the writing becomes ornament; for those who know the Persian language, it forms chains of associations. To describe such a space covered with writing, the artist uses the German term "Schriftraum" – "Written Rooms" charged with the dynamic energy of calligraphy. Signatures and words with visible and invisible meanings dance along the walls. In her installation "Bodyletter" of 2008 (pp. 22-25), Forouhar collaborated with the Syrian-Turkish dancer Ziya Azazi. This work combined the driving lines and rhythms of calligraphy, which Forouhar applied with transfers onto the floor of the auditorium, with Azazi's choreography, a language of gestures and the gyrating movements of Sufi dance.

The exhibition "Tausendundein Tag" ("A Thousand and One Days", pp. 70-73) of 2003 contained the key to much of Forouhar's work up till now. Here the mythological fantasy-world of "A Thousand and One Nights" is shattered and has turned into its opposite. The dream has become the desperate nightmare of a dysfunctional society. The viewer takes part in the disillusioned awakening into a reality of imprisonment, torture and death. While in "Home Address" the viewer was still enveloped in an abundance of calligraphic gestures and signs that covered every surface of the inscripted space, in "A Thousand and One Days" Forouhar covered the walls with printed wallpapers, creating a space filled with silent screams.

At first glance these wallpapers seem to be purely decorative, covered with irregular patterns in pink and black on a white background. Seen in close up, however, they reveal scenes of torture, of suffering bodies suspended in time. They are in fact a pictographic vocabulary of women being tortured according to Sharia law: by beating, stoning, strangling and hanging. By multiplying these pictograms, each a signature of a specific kind of humiliation or brutality, they grow into an ornamental language of their own.

These wallpapers do not paste over reality, instead they uncover forcefully the repression and brutality of a society in which the citizen is held prisoner. Kaleidoscopic images create an unbearable tension between the horrors they represent and the ornamental beauty of the compositions. Forouhar has said of this body of work: "There is this sensuous, aesthetically gratifying aspect to it all. It is beautiful. But the moment the appearance of beauty disintegrates and turns into cruelty, you have to bear the resulting ambivalence, particularly because the beauty is not lost in the process. In terms of the perception of the work, this moment is very important… At first glance, you see the beautiful pattern and think you have understood it. And then you get closer and realise it is completely different. The viewer is thrown back on himself and is forced to re-evaluate his perception."[4]

Propaganda and terror are always employed together, they are inseparable. A society exposed to these totalitarian forces lives in a condition of paranoia and fearful anticipation. This affects those who govern, their henchmen, as well as their potential enemies and victims. The misogyny inherent in fundamentalist religion gives Iranian society a particularly frightening edge, in which women are the preferred victims. The psychological interaction of victim and executioner is de-personalised. Within the circle of infliction and endurance of pain, both murderer and victim lose their individuality. As in Kasimir Malevich's paintings of faceless peasants who lost their identity during the enforced Soviet collectivization programme, the tortured women in Forouhar's images have also lost their faces. They wear black chadors and blindfolds. Black is their hair, black are their shackles and the ropes that tie them to their torturers, who are faceless, too, in their terrible anonymity. The procession of death seems to move on relentlessly.

Two computer-animated films with the same visual language are "Spielmannszüge" ("Marching Bands", pp. 88-89), and "Just a Minute" (p. 90). In the first, a choreographed circular dance of tragic monotony, human figures are beaten, strangled and hung. As in her graphic work, the figures have simple silhouettes of schematic uniformity – every sign of individuality is wiped out. In the second, groups of figures, growing repeatedly in size and density, are extrapolated in mirror-symmetrical patterns and eliminated. The looped-up movements of these human/inhuman ornaments reveal the amoral mechanism of a totalitarian system that randomly decides over life and death. These films contain symbolic reminders of the brutalisation of our mass media and reflect on the voyeuristic passivity of "uninvolved" citizens. The link from perpetrator to victim is extended to the bystander.

Forouhar has embarked on a continuing production of prints on paper that explore various configurations on the theme of torture. In her depiction of everyday mental and physical brutality, she creates images of aesthetic appeal but disturbing ambiguity. References to the tradition of Persian miniatures are forever present and are fused by computer techniques into a complex imagery of both modern and traditional meaning. Surfaces of colourful Oriental beauty are broken down through geometric shifts and fault lines, building interlaced layers of image elements. Like M.C. Escher's "Metamorphoses", Forouhar's prints create images within a labyrinth of images, figures dissolved in the entanglement of ornamentation, prisons lost in the infinite spaces of geometry.

A group of fifty printed fabrics, "Eslimi" ("Ornaments", pp. 92-97), are bound together in pattern books. Here ornamental patterns are printed in a tight grid of rhythmic repetition. Their beauty entraps the viewer, but the apparent calm of their surfaces is deceptive. For this work Forouhar has developed an even more abstracted range of iconic signs. Fitting the secretive culture of the torturers, she created finely simplified and stylised pictograms of individual instruments for the infliction of pain and death, such as whips, knives, scissors, forks, needles, knuckledusters and pistols. Another series pictures constellations of stylised male and female genitals, reminding the viewer of sexual humiliation and rape. Genitals entwined in curls of wires contain references to the deviousness of electric-shock torture. John Berger suggested in view of the development of art in the age of reproduction and digital multiplication: "The art of the past no longer exists as it once did. Its authority is lost. In its place there is a language of images. What matters now is who uses that language for what purpose."[5] Parastou Forouhar's work contributes to the creation of that new visual language; she uses it within the defined purposes of her art.

Lutz Becker, London 2010

[4] Interview with Brigitte Werneburg, culture editor of *Die Tageszeitung*, on the 2004 exhibition curated by Rose Issa, "Entfernte Nähe" ("Far Near Distance") at the Haus der Kulturen der Welt, Berlin
[5] John Berger, *Ways of Seeing* (BBC/Penguin Books, London 1972)

BODYLETTER
1995-2010

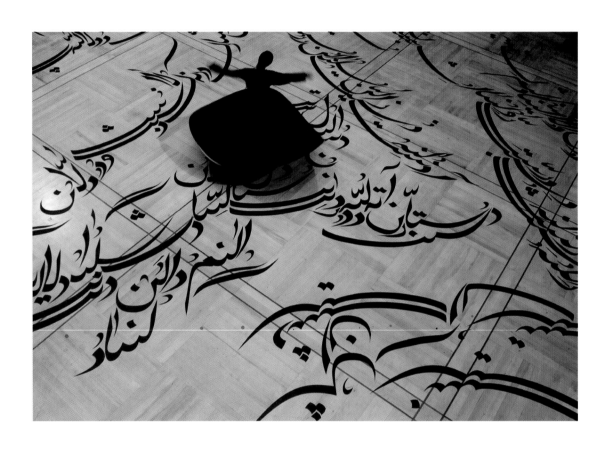

"Bodyletter", installation of digitally-cut plastic foil, in association with ha'atelier and Ziya Azazi, Eugen Gutmann Haus, Berlin (2008

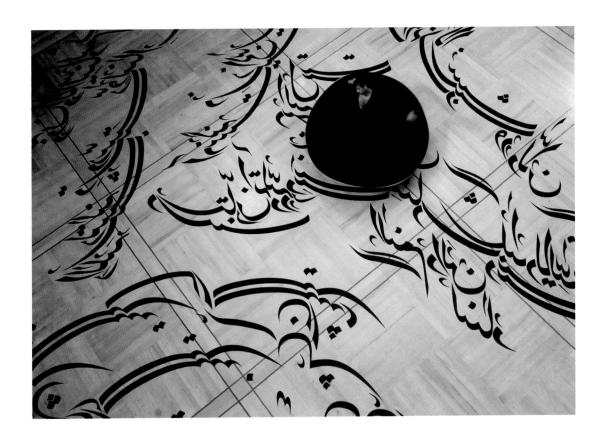

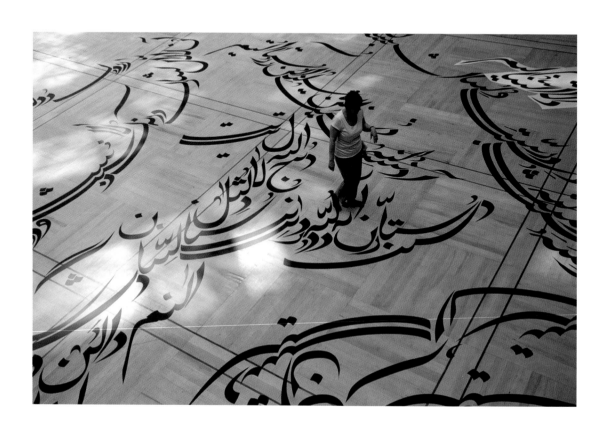

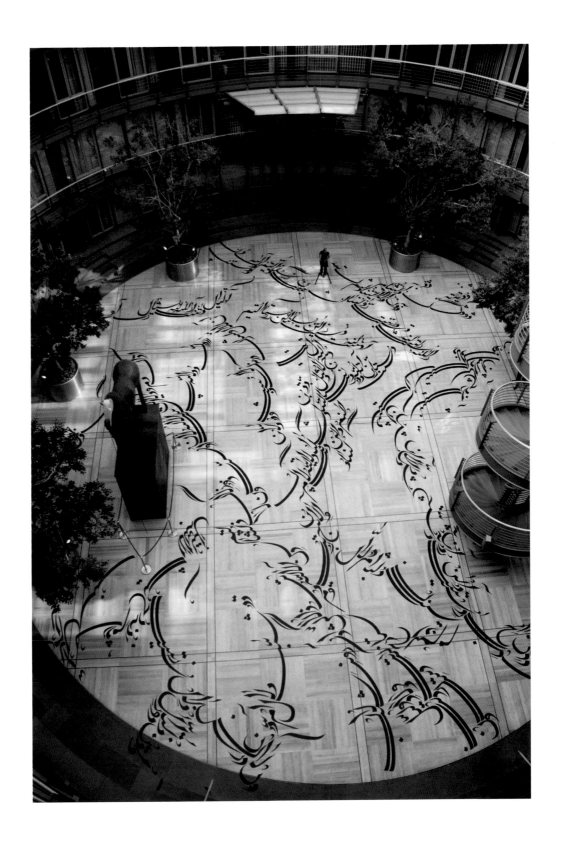

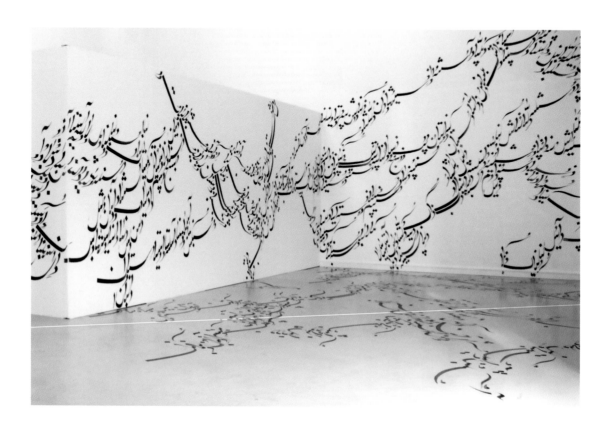

"Written Room", acrylic paint, installation at the Incheon Women Artists' Biennale, South Korea (2009)

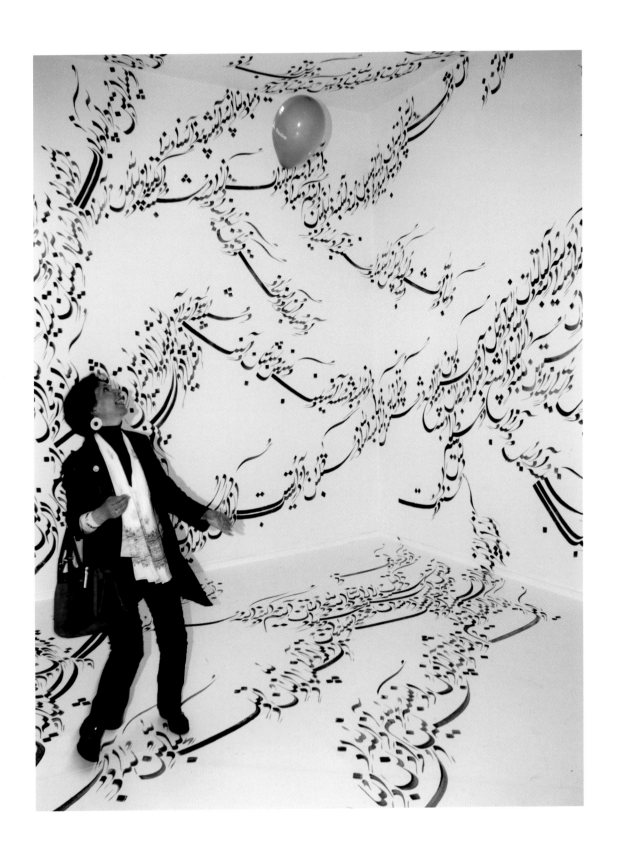

"Written Room", acrylic paint, installation for "Veiled Memoirs", XIV Biennale Donna, Ferrara (2010) 27

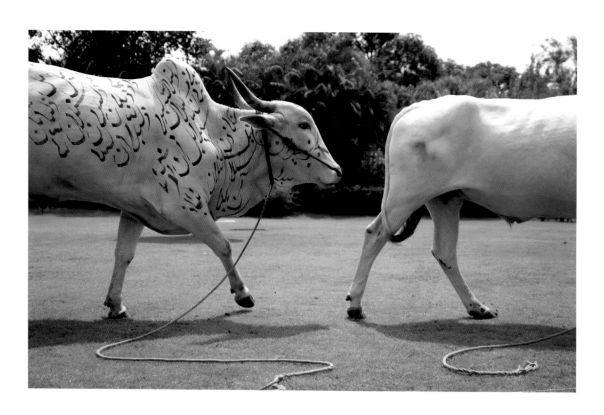

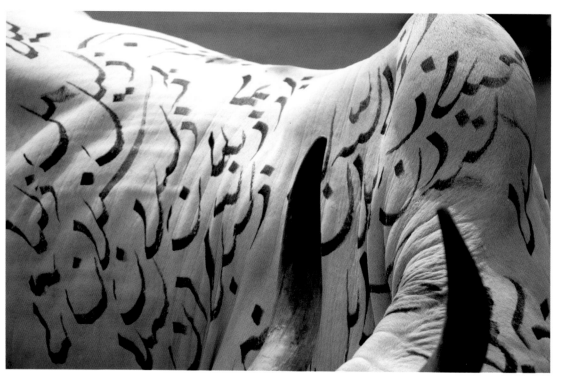

"Elsa's Anunciation", digital print on Alu Dibond, 70cm x 46cm (2005)

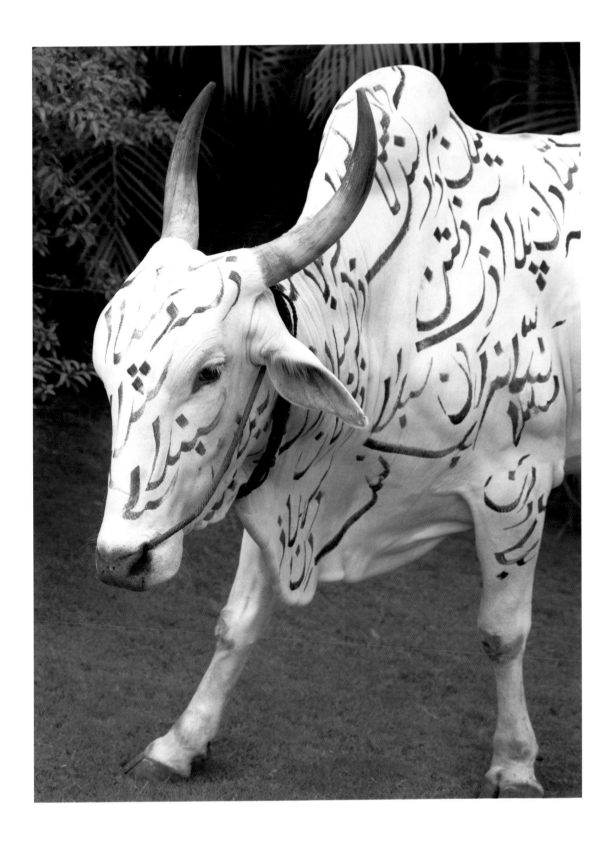

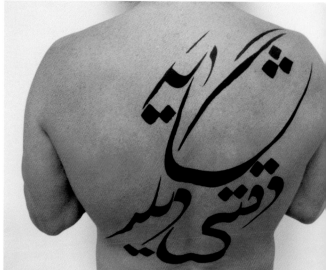

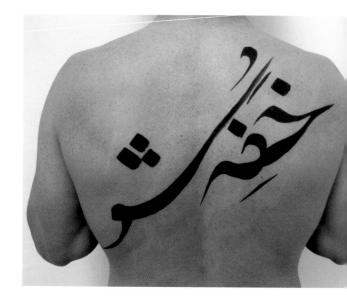

Top left: "Get Lost". Top right: "Maybe Later". Above: "Shut Up". Opposite: "Cloudy".
Model: Dennis Paeschel. Digital prints, all 20cm x 15cm (2006)

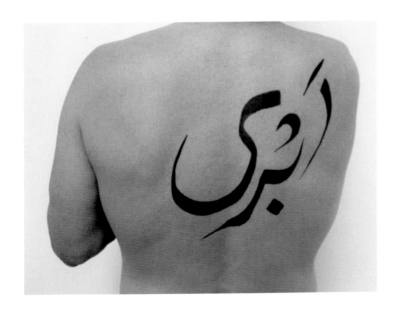

COMMEMORATION
2003-2010

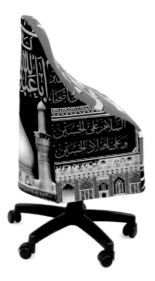
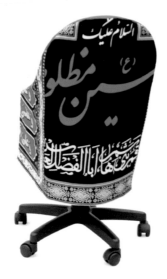
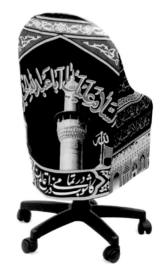

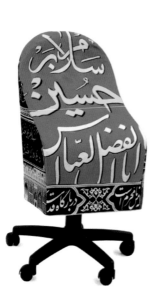
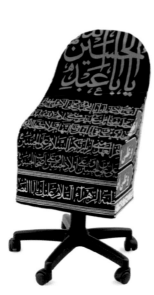
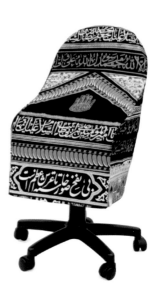

34 "The Funeral", office chairs and fabric, details from a series of installations (2003-2010)

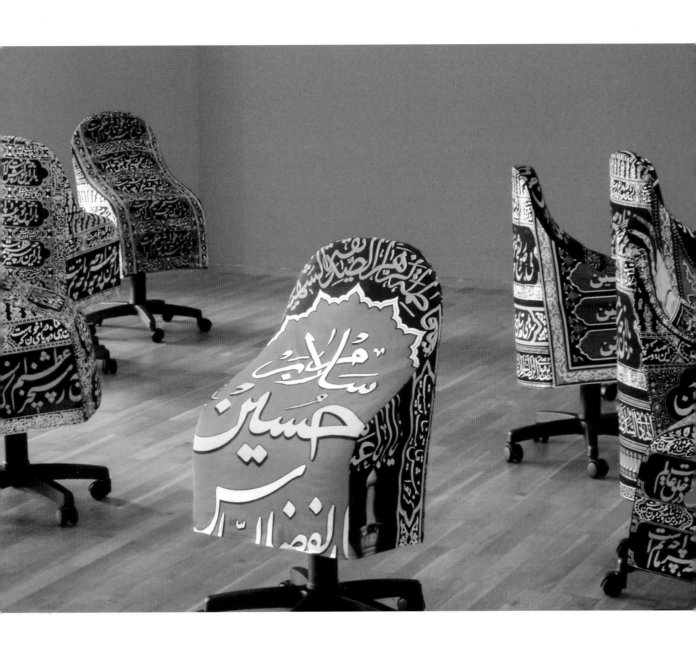

"The Funeral", installation for "A Thousand and One Days", National Gallery Hamburger Bahnhof, Berlin (2003)

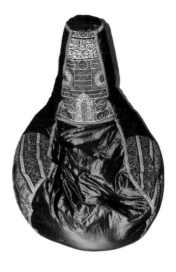

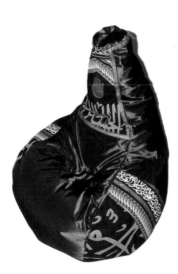

"Countdown", mixed media, details from a series of installations (2008-2010)

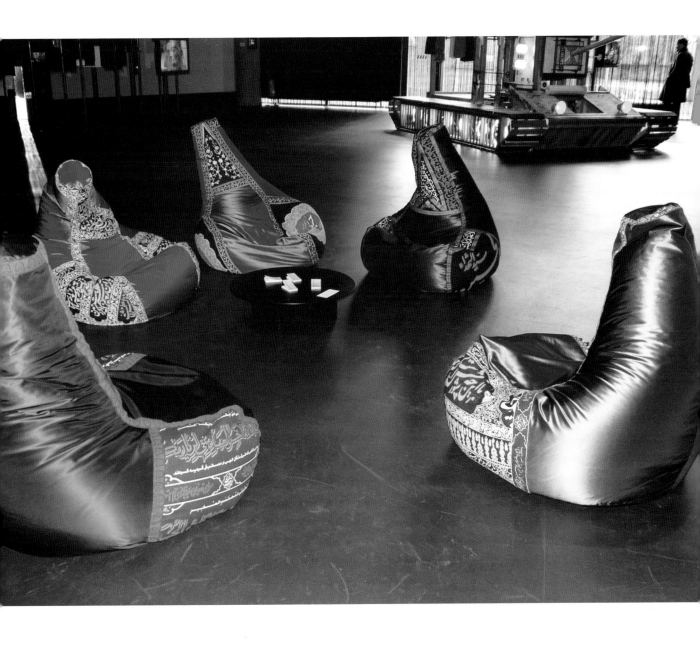

"Countdown", installation for "Re-Imagining Asia", House of World Cultures, Berlin (2008) 37

"Safari" (detail), installation for "Intersections", The Jewish Museum of Australia (2005)

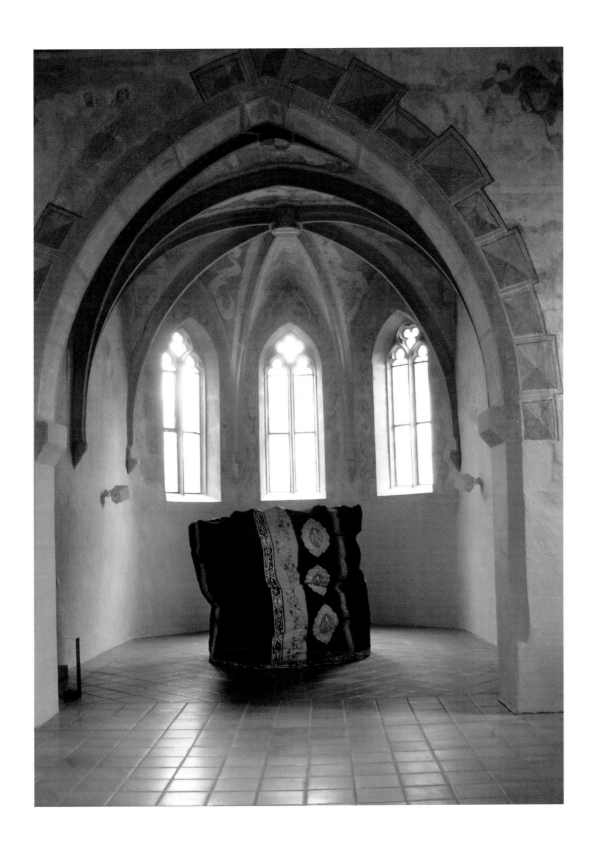

"Safari", mixed media, installation for "The Language of Ornaments", Stadtmuseum, Crailsheim, Germany (2004)

ESLIMI
2003-2010

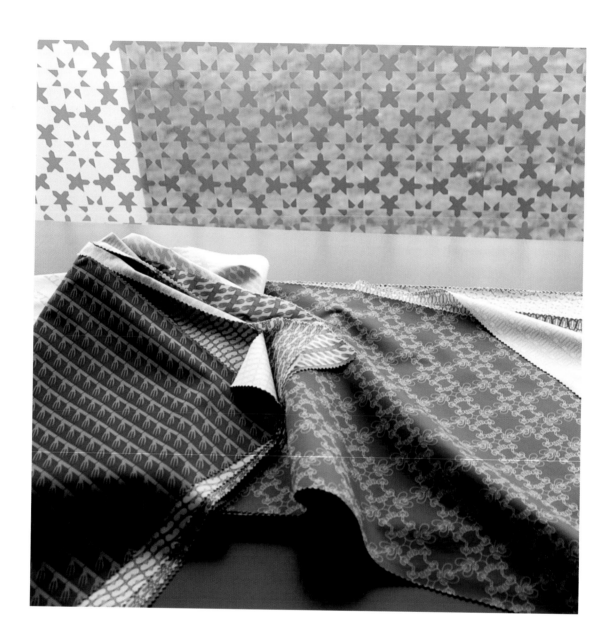

"Eslimi" series (detail), printed fabric-pattern book, for "Mahrem", Kunsthalle Vienna (2008)

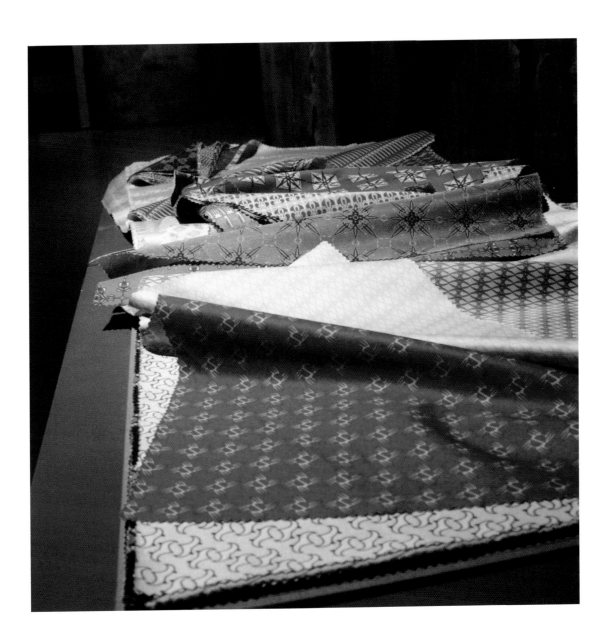

"Eslimi" series (detail), printed fabric-pattern book for "Mahrem", Santralistanbul, Istanbul (2007)

44 "Guns", from the "Eslimi" series, digital prints on fabric, all 594cm x 420cm (2003-2010)

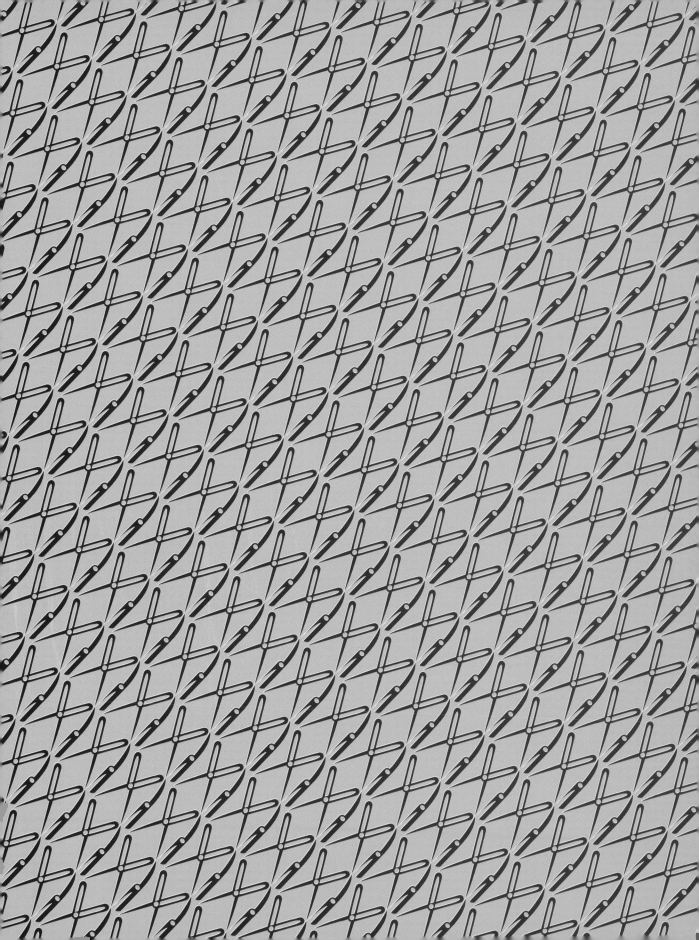

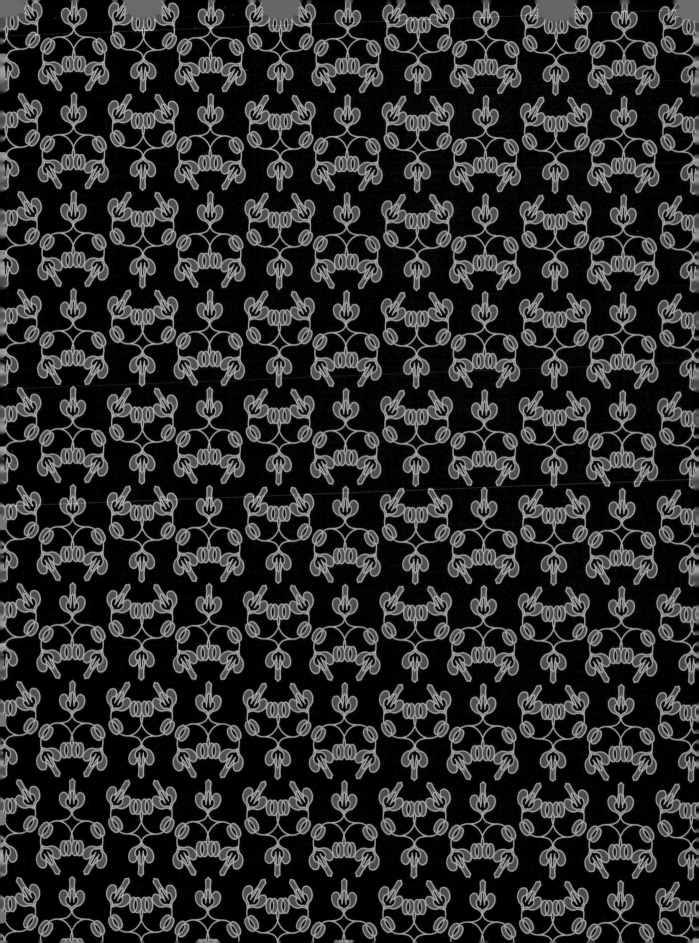

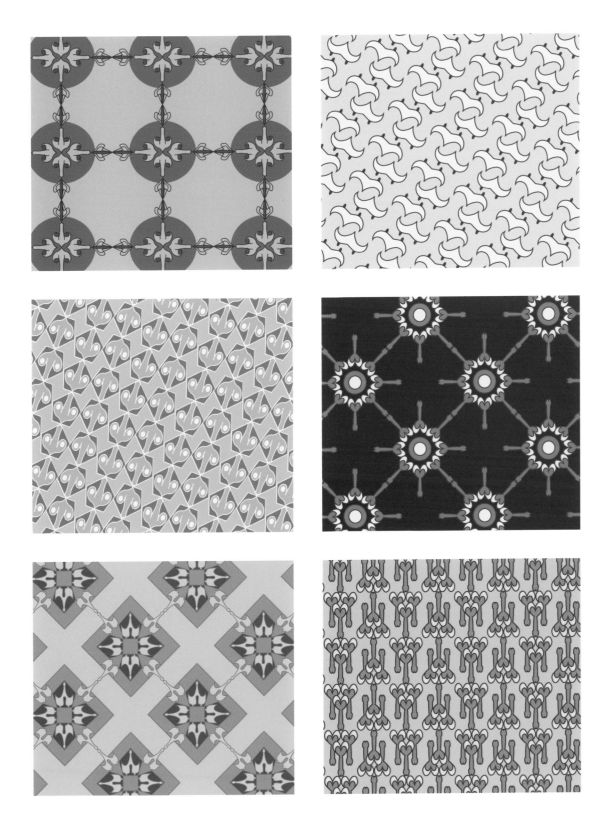

"Genitals", from the "Eslimi" series, digital prints on fabric, all 594cm x 420cm (2003-2010)

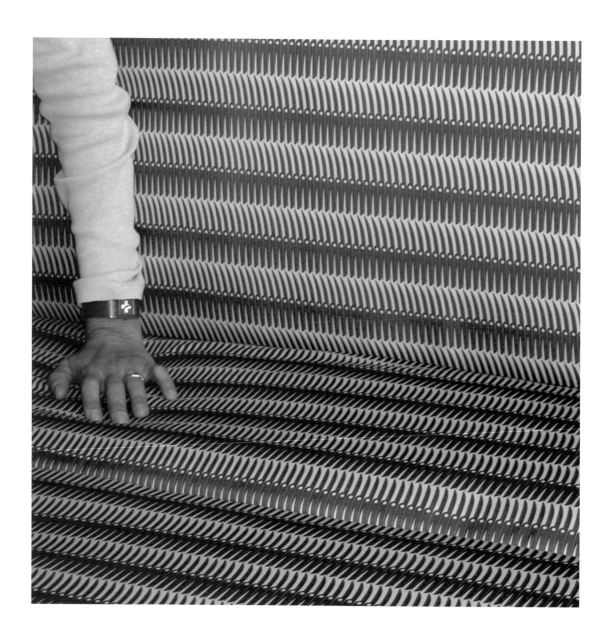

"Chamber" (detail), industrial storage container, digital print "Knives" fabric and cotton padding, 2m x 2m x 1.8m (2004)

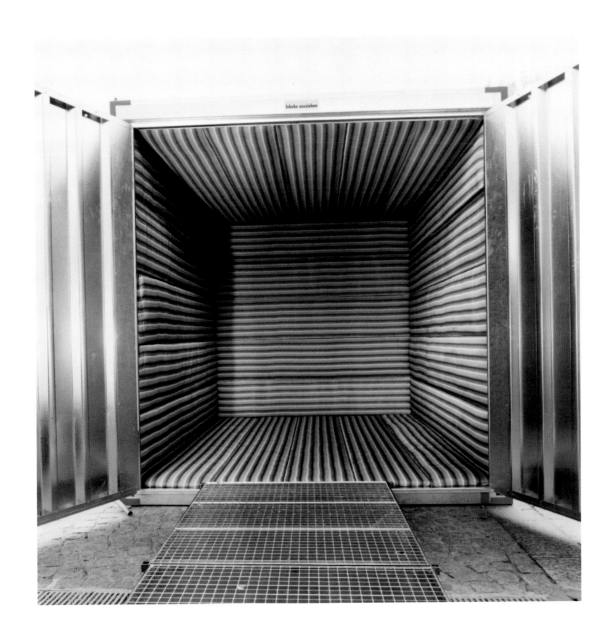

"Chamber", installation for "Far Near Distance", House of World Cultures, Berlin (2004)

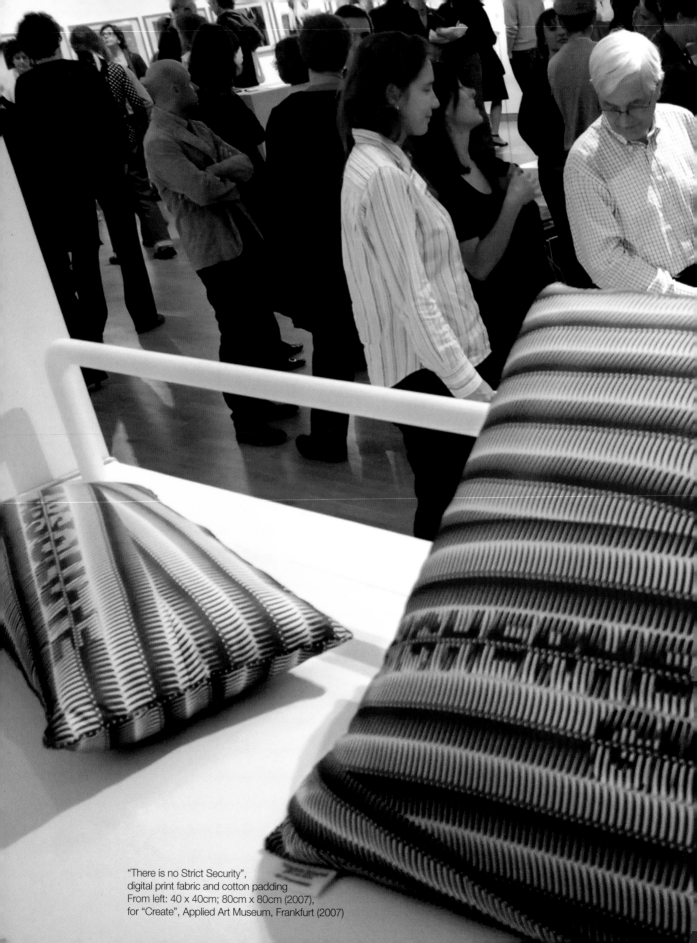

"There is no Strict Security",
digital print fabric and cotton padding
From left: 40 x 40cm; 80cm x 80cm (2007),
for "Create", Applied Art Museum, Frankfurt (2007)

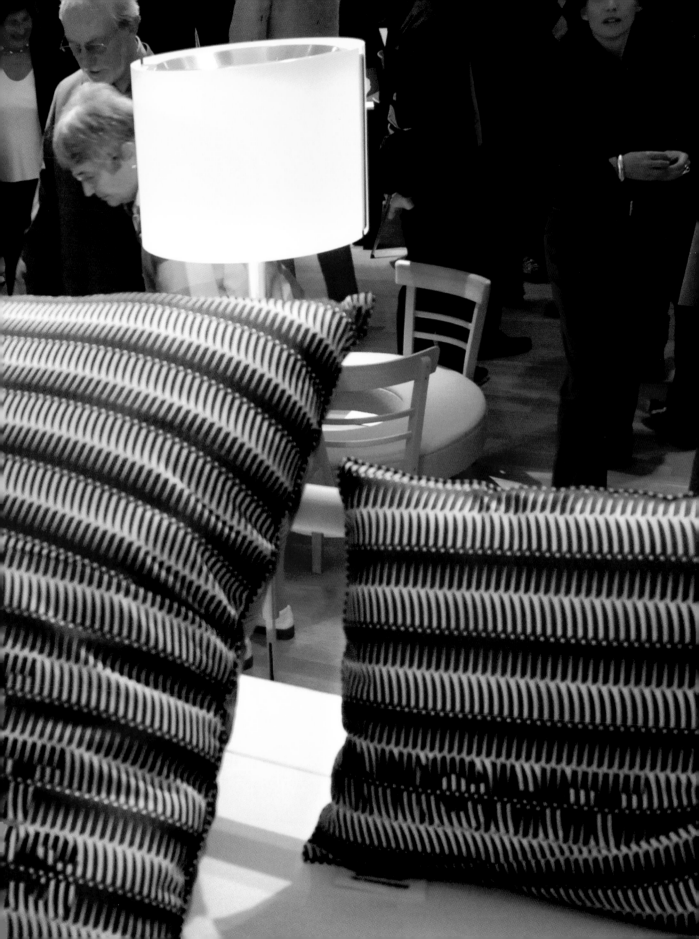

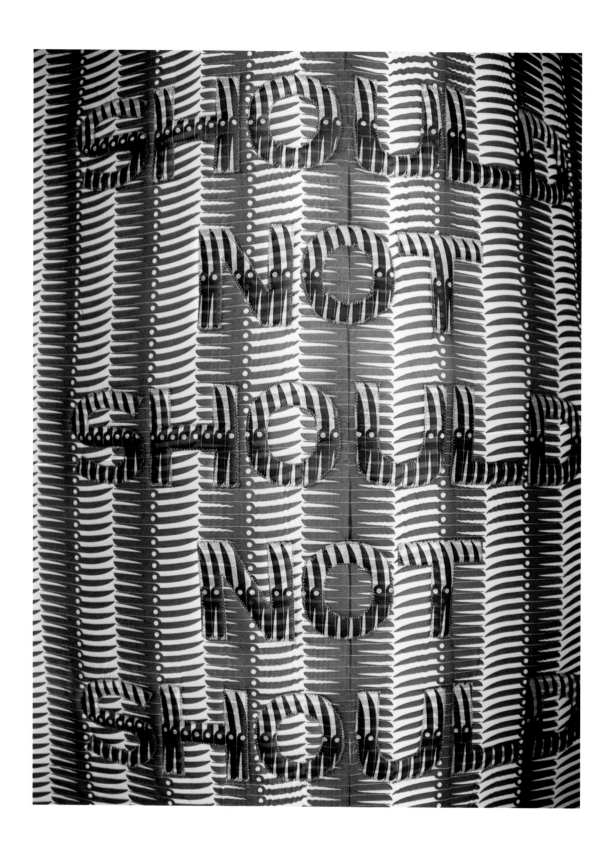

52 "Should Not Should" (detail), appliqué digital print fabric on liner cloth, 180cm x 200cm (2008)

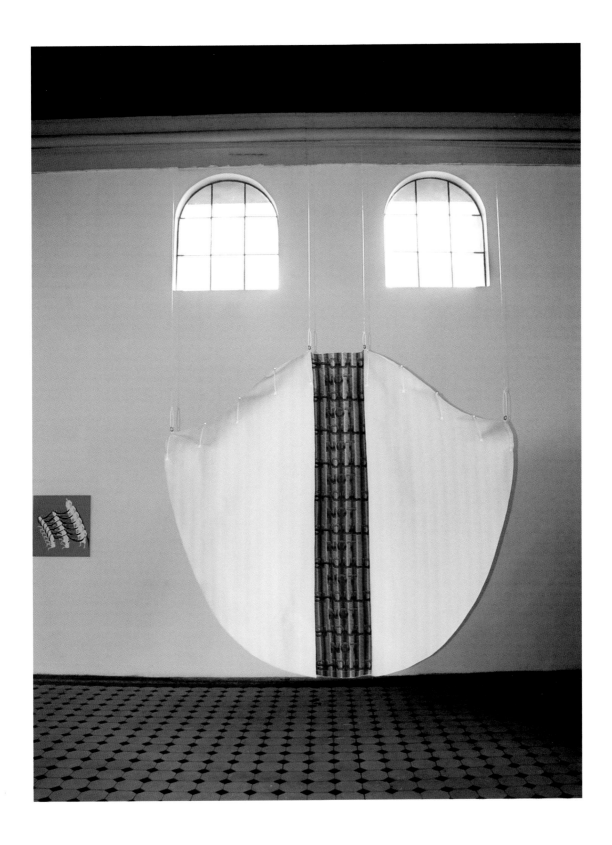

"Should Not Should", installation for "Parade", Kunsthalle Vierseithof, Luckenwalde (2008)

DIGITAL DRAWINGS
2003-2010

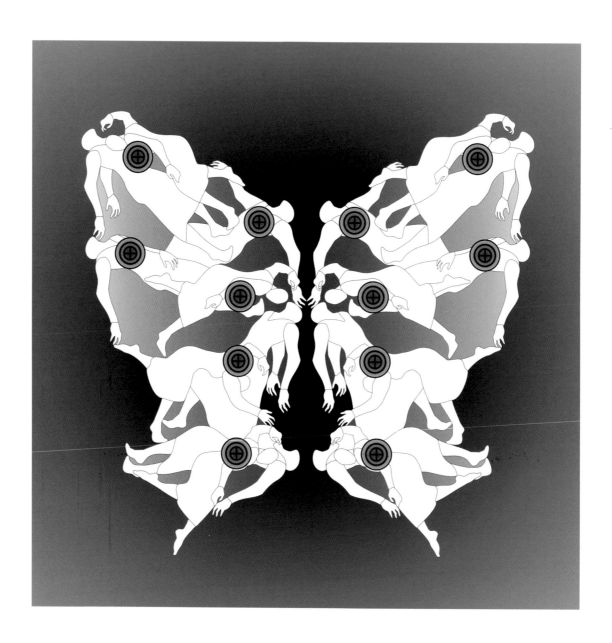

"November 22nd" from the "Papillon Collection", digital print on Photo Rag, 100cm x 100cm (2010)

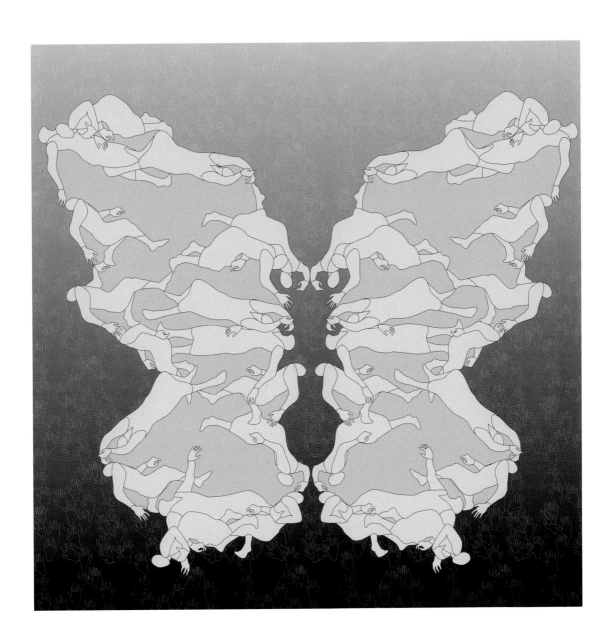

"Khavaran Cemetery" from the "Papillon Collection", digital print on Photo Rag, 100cm x 100cm (2010)

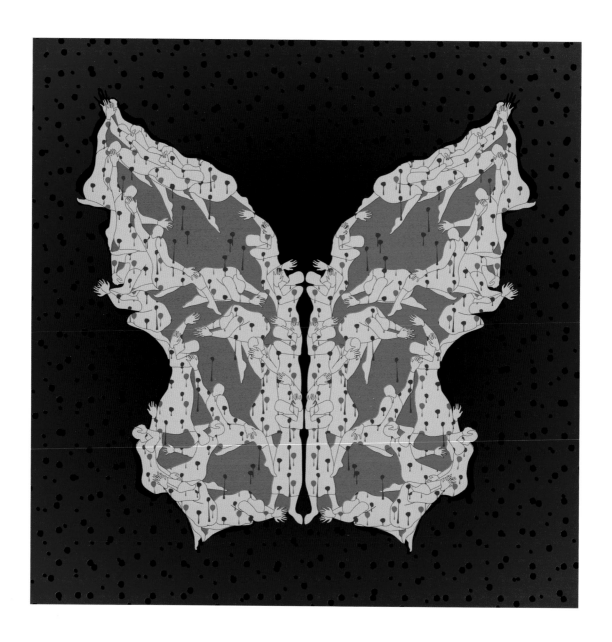

58 "Ashura Day" from the "Papillon Collection", digital print on Photo Rag, 100cm x 100cm (2010)

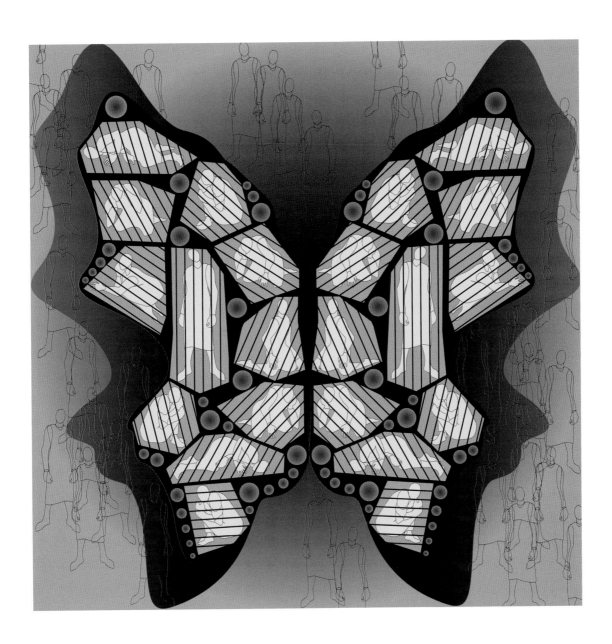

"Ewin Prison", from the "Papillon Collection", digital print on Photo Rag, 100cm x 100cm (2010)

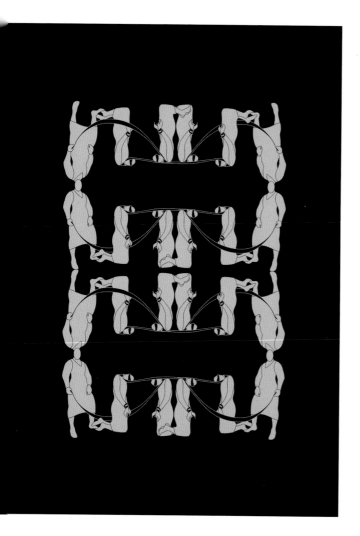

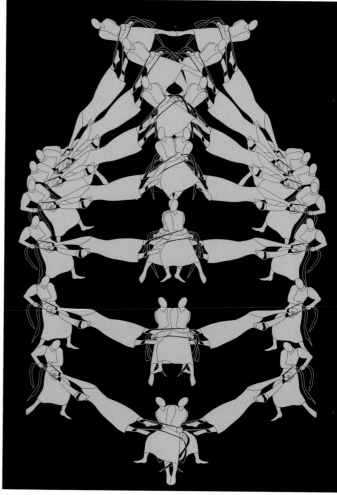

"A Thousand and One Days I", series of 8 digital drawings, digital print on Photo Rag, all 297cm x 420cm (2007)

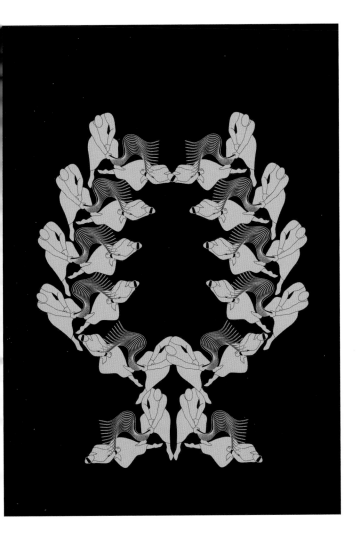
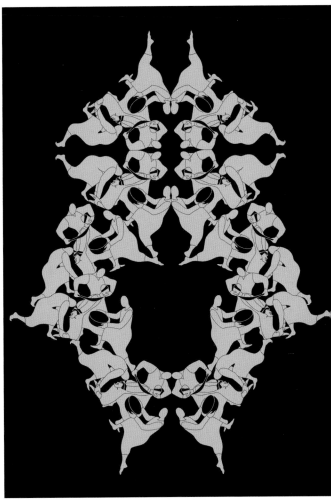

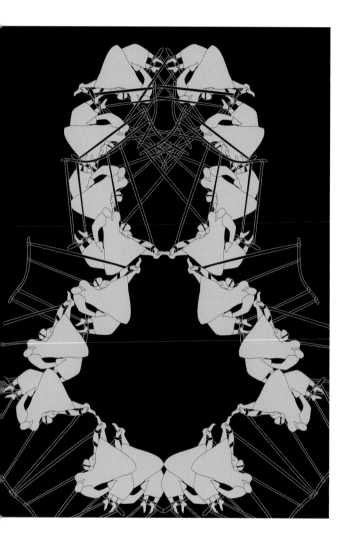

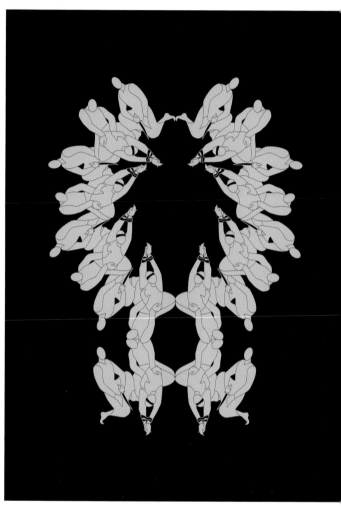

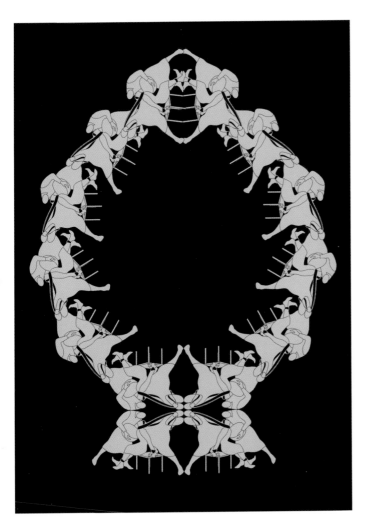
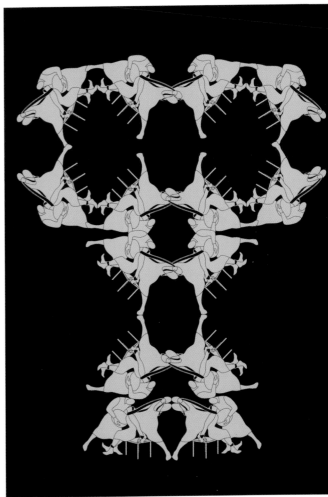

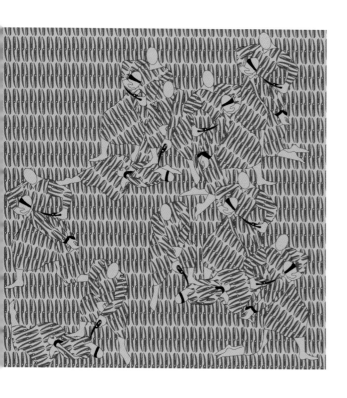
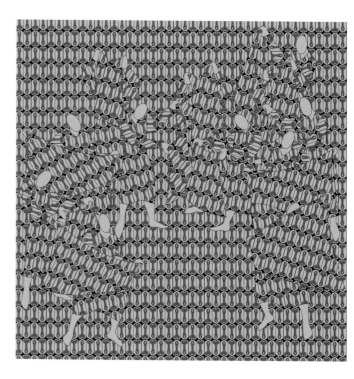
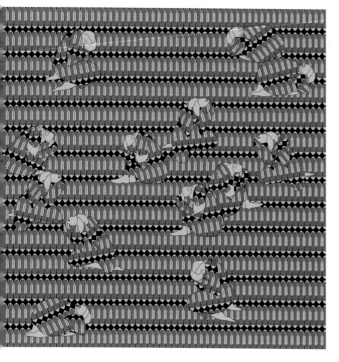
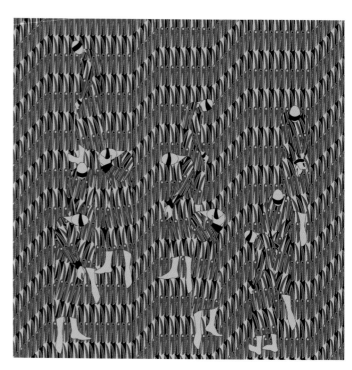

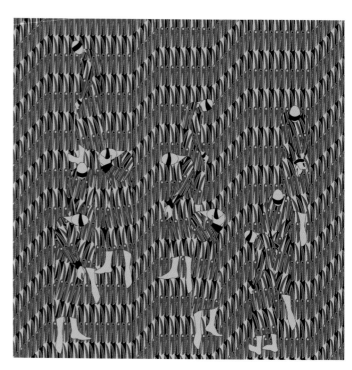

64 "Red is my Name, Green is my Name I", series of 8 digital drawings, digital print on Photo Rag, all 40cm x 40cm (2007)

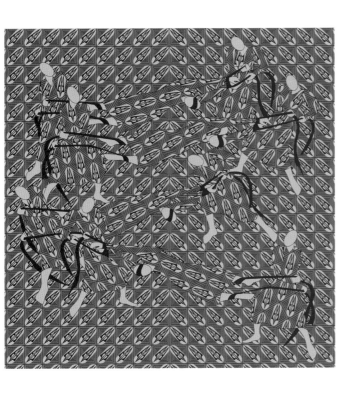

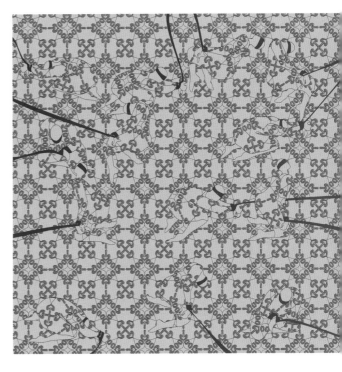

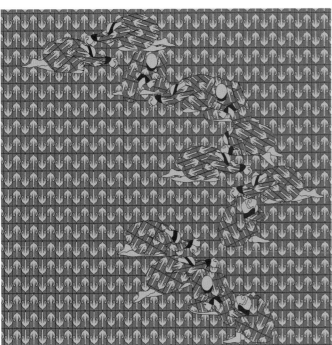

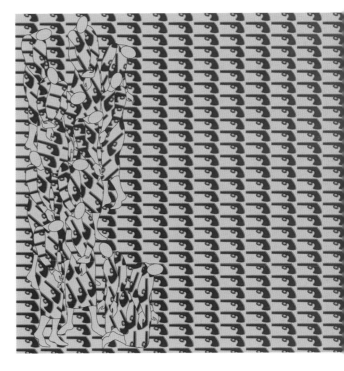

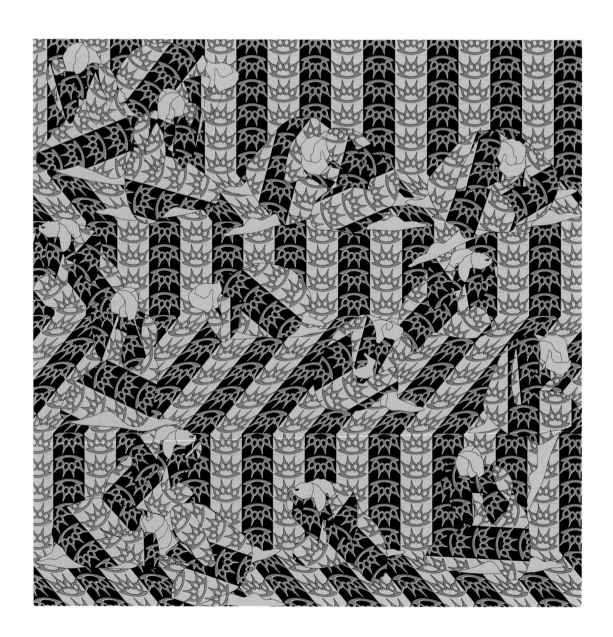

"Red is My Name, Green is My Name II", series of 4 digital drawings, digital print on Photo Rag, 50cm x 50 cm (2009)

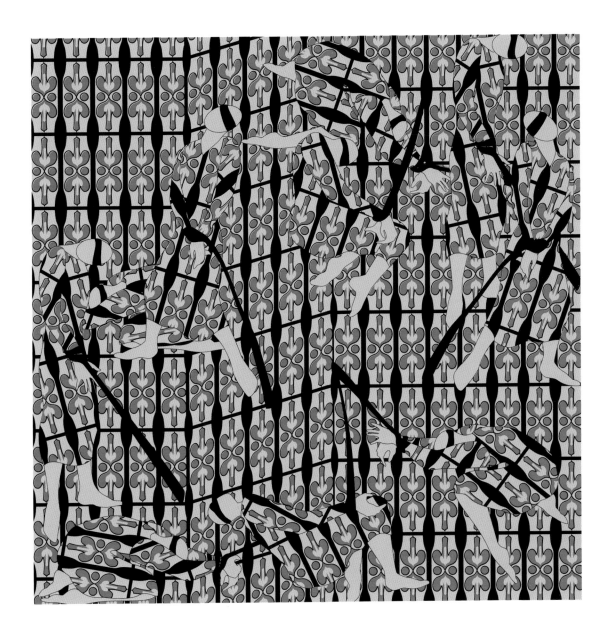

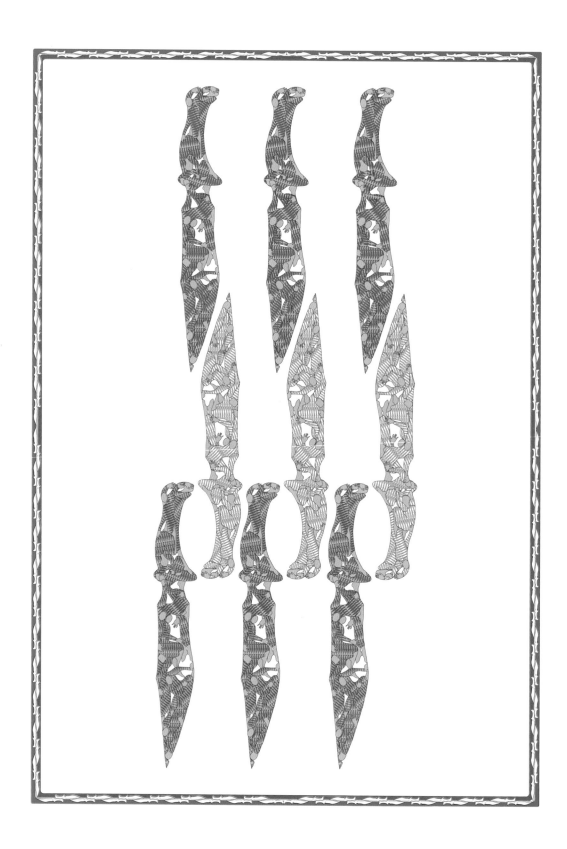

"Flag Collection – Knives", digital print on Photo Rag, 100cm x 70cm (2010)

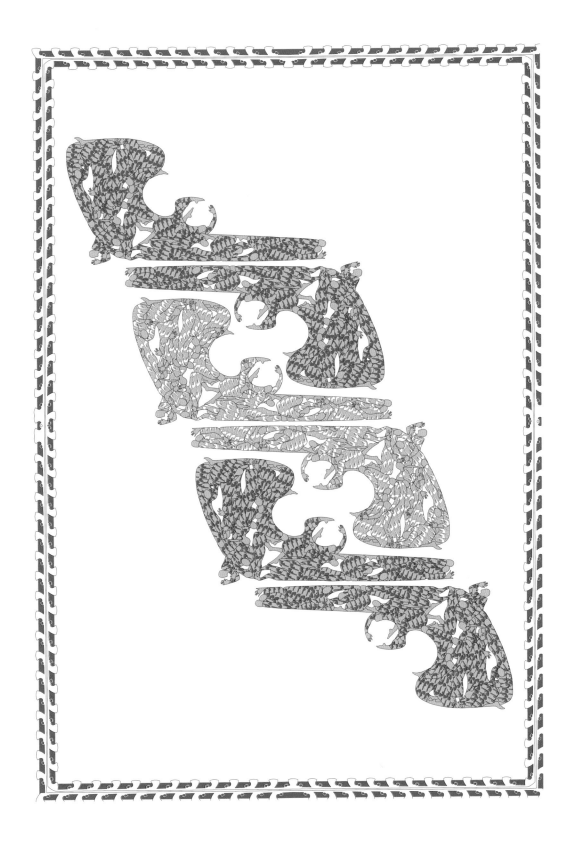

"Flag Collection – Revolvers", digital print on Photo Rag, 100cm x 70cm (2010) 69

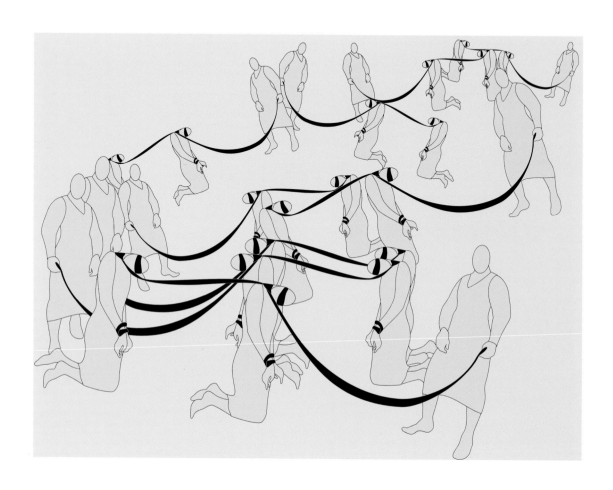

"A Thousand and One Days II", series of 5 digital drawings, digital print on Photo Rag, 30cm x 40cm (2009)

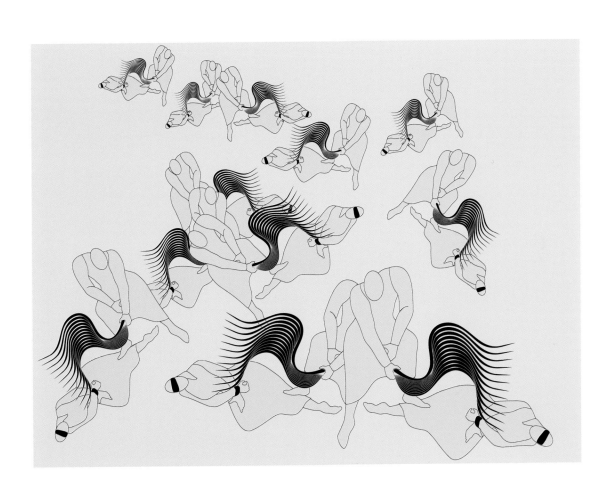

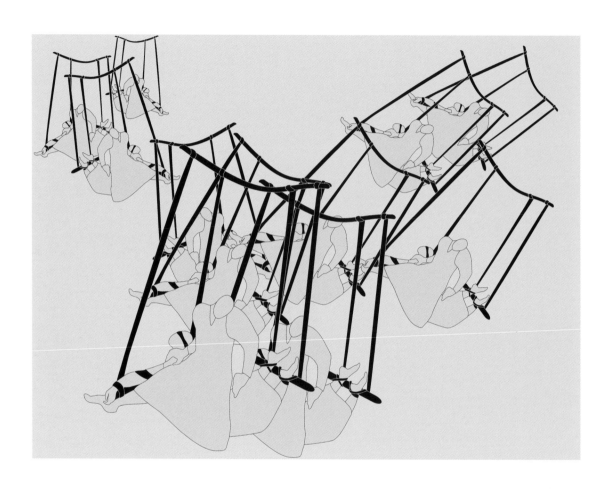

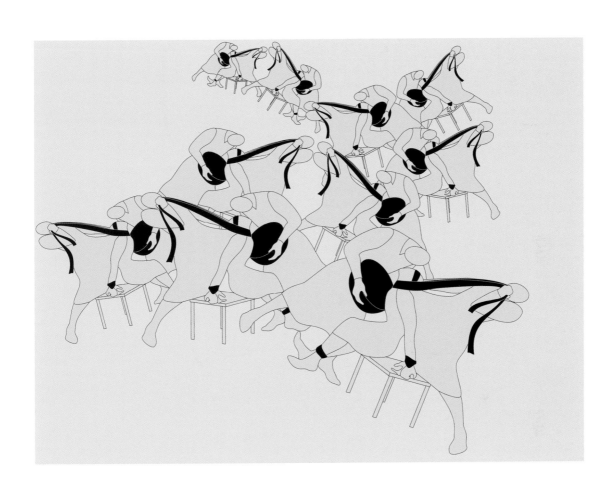

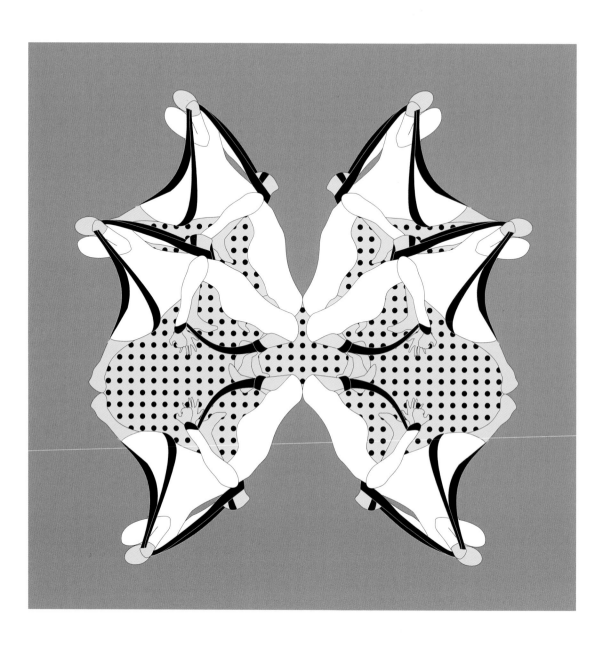

"Parade", series of 4 digital drawings, digital print on Alu Dibond, 64cm x 64cm (2008)

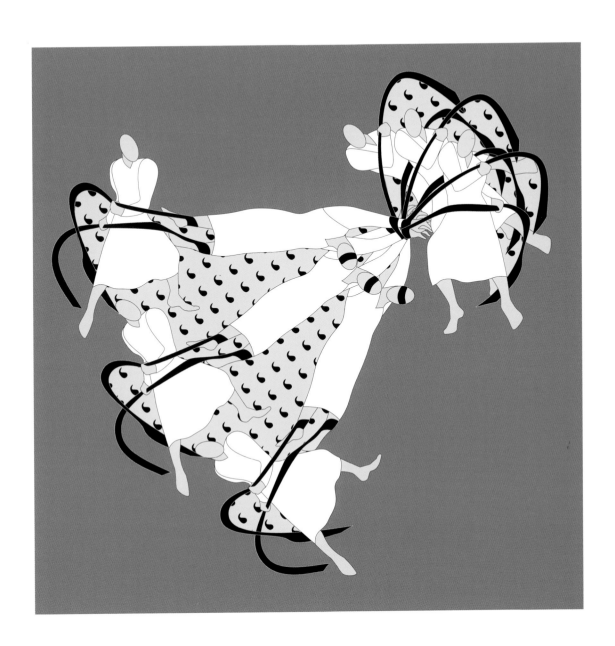

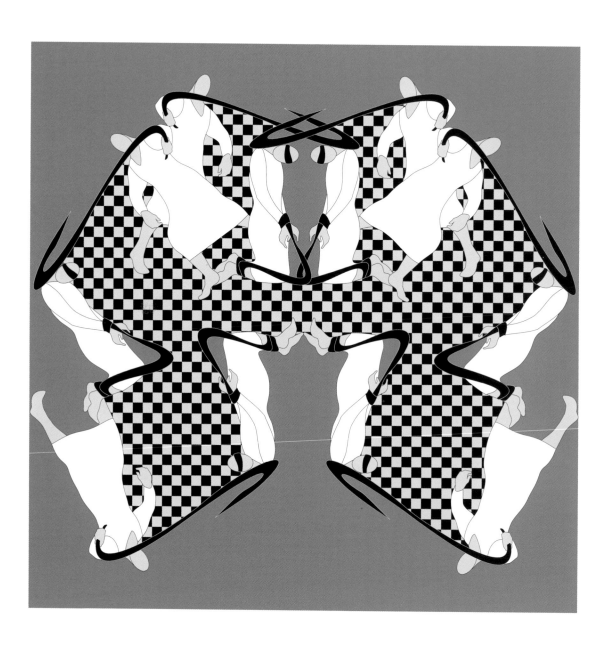

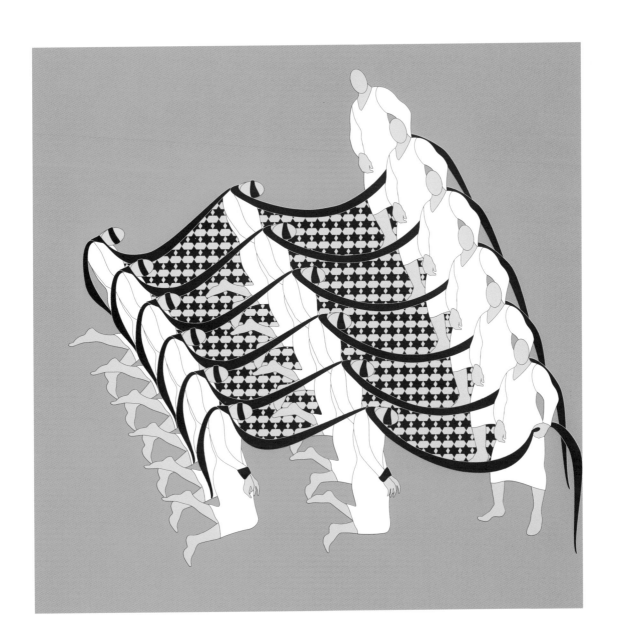

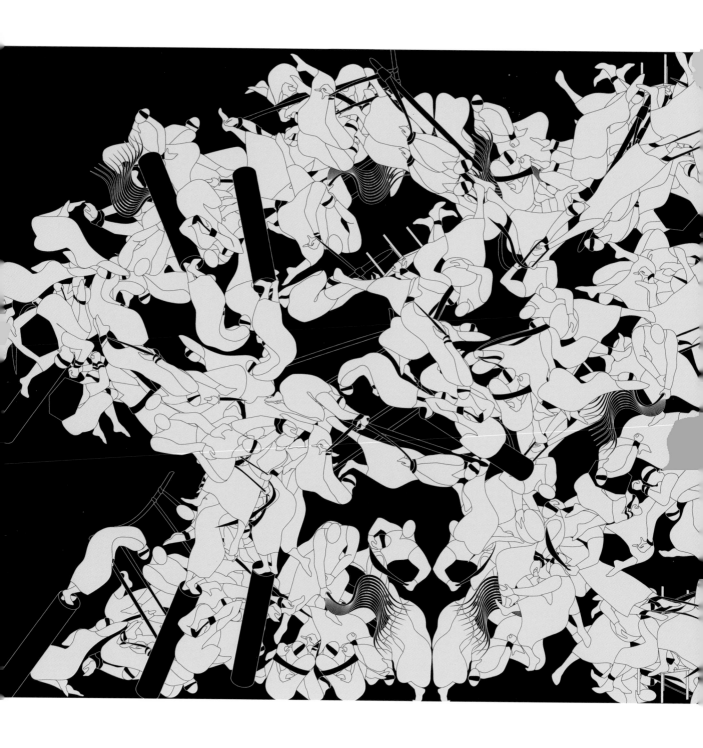

"A Thousand and One Days – Panorama", digital print on paper, 145cm x 326cm (2006)

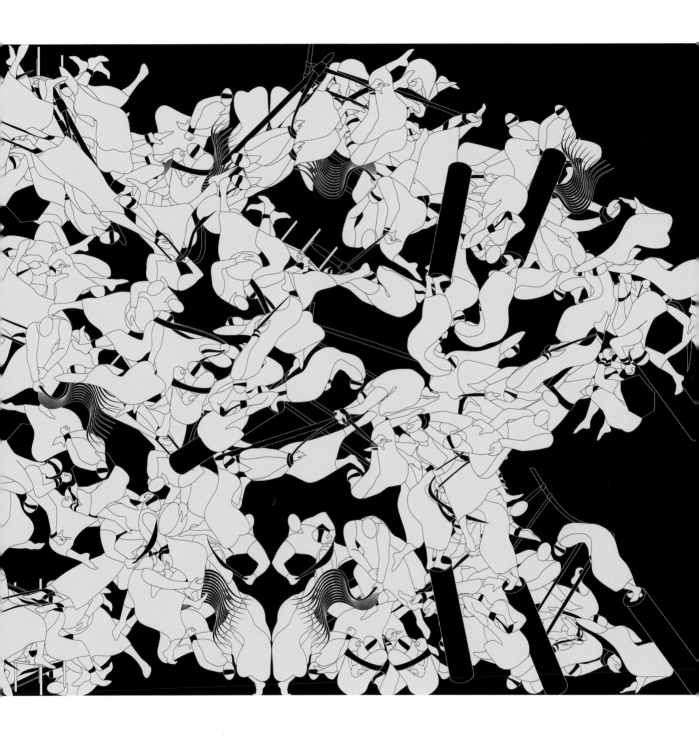

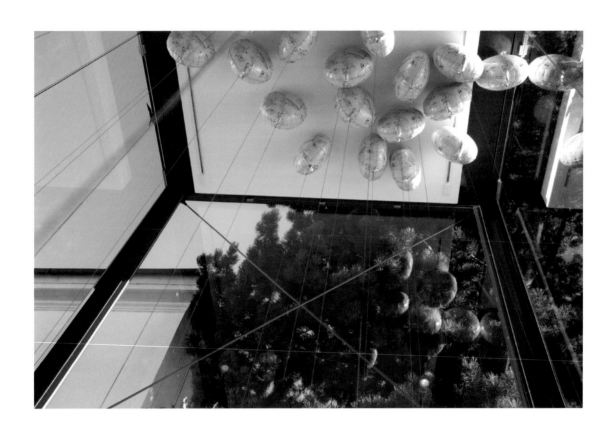

"I Surrender", digital print on helium balloons with black laces, installation for "The Power of Ornament", Belvedere, Vienna (2009)

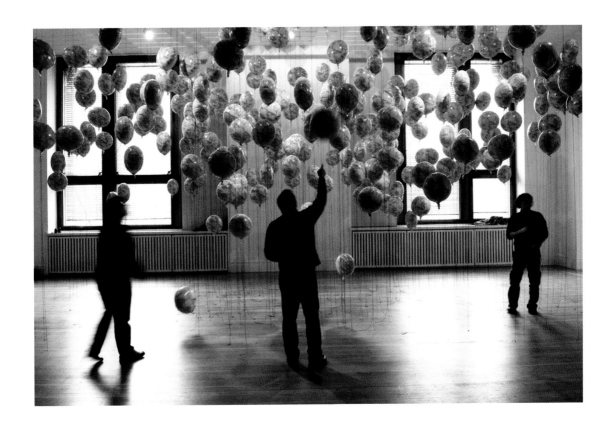

"I Surrender", installation at the Martin-Gropius-Bau, Berlin (2007)

ANIMATION & WALLPAPER
2001-2010

SCHUHE AUSZIEHEN

von
Parastou Forouhar

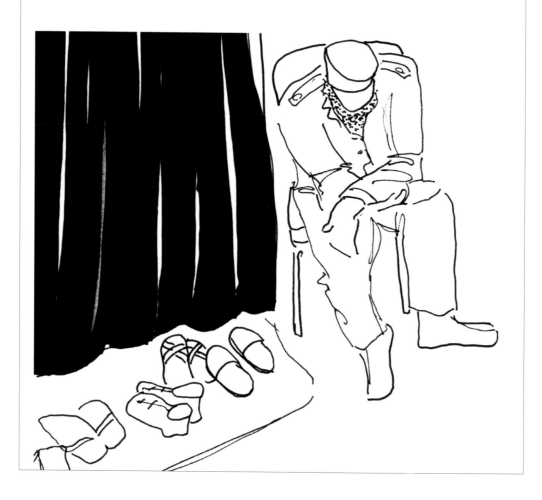

"Take Off Your Shoes", hand-drawn stills from animation (2004)

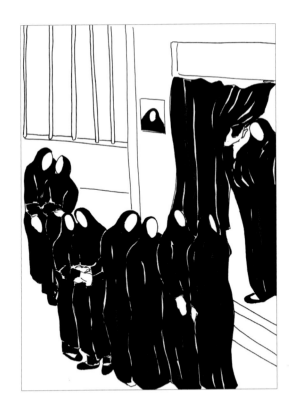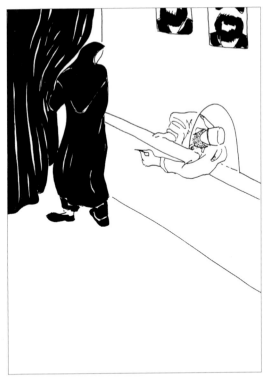

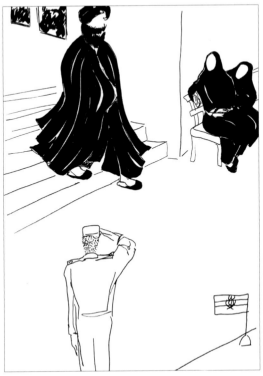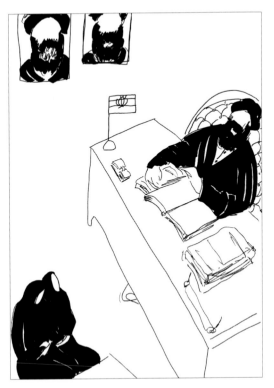

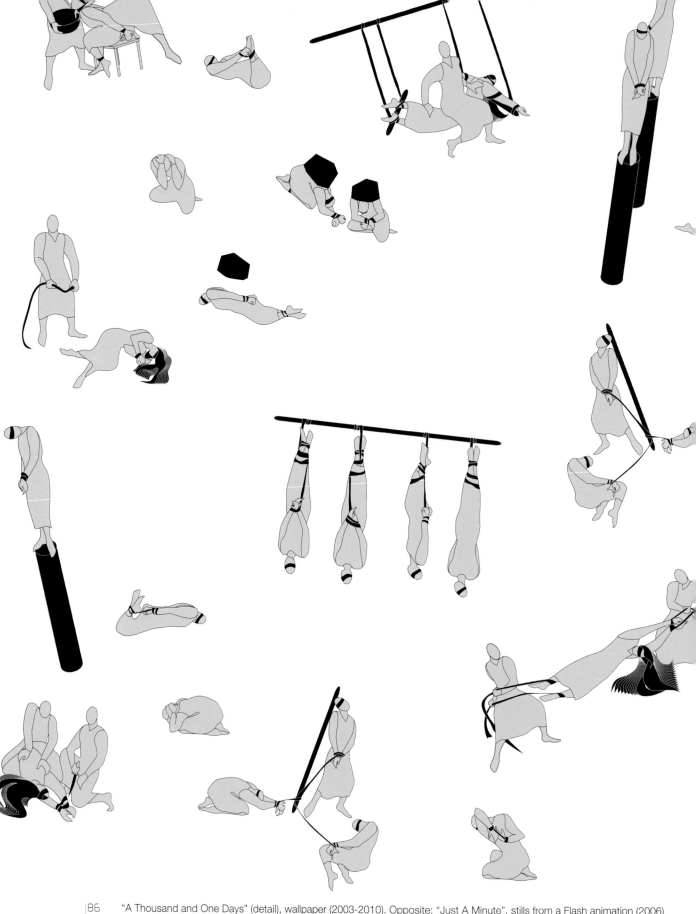

"A Thousand and One Days" (detail), wallpaper (2003-2010). Opposite: "Just A Minute", stills from a Flash animation (2006)

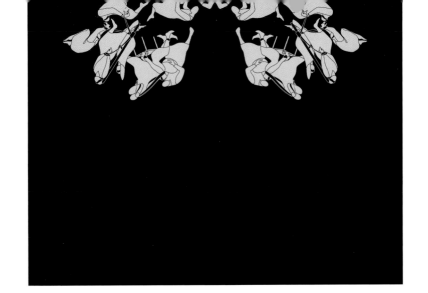

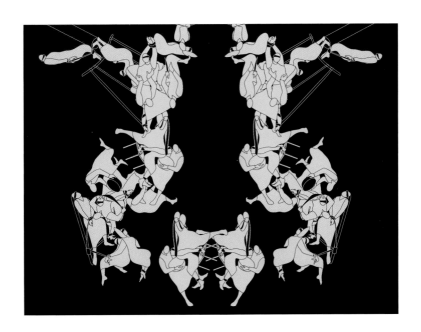

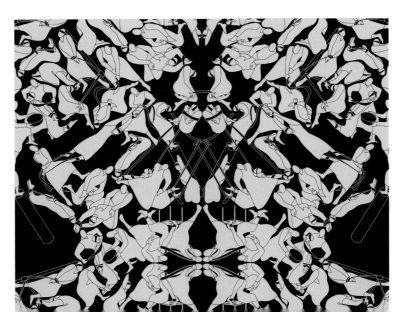

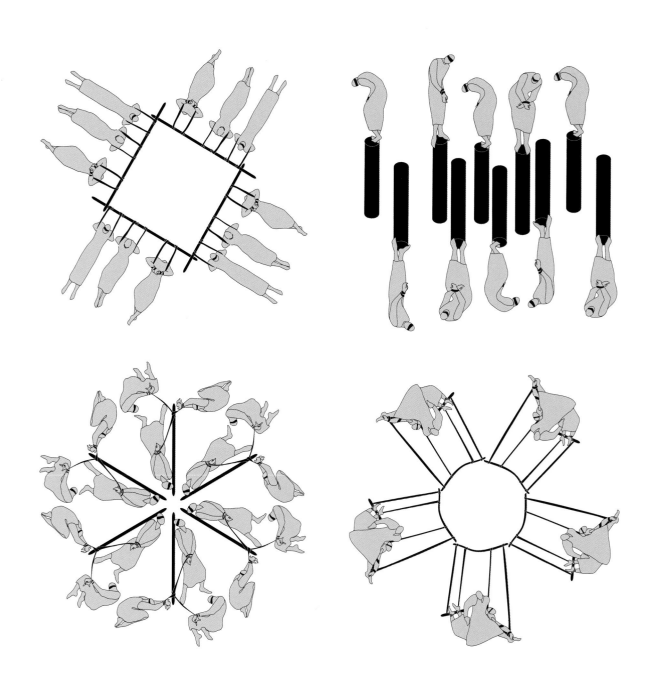

"Marching Bands", stills from a Flash animation (2005)

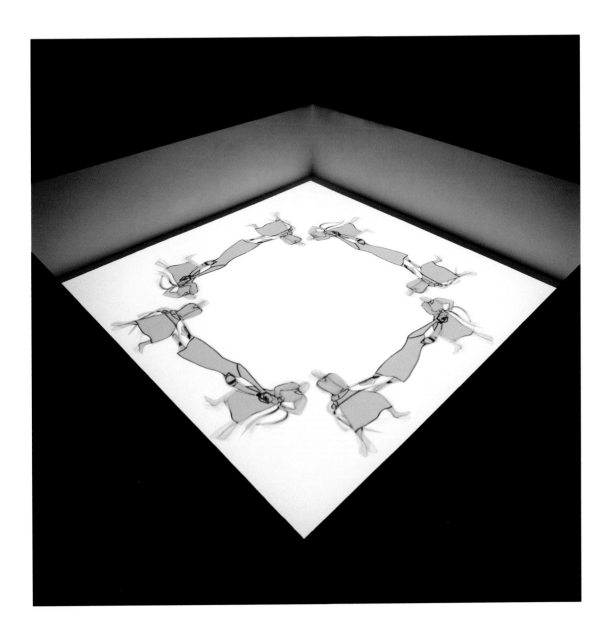

"Marching Bands", installation at the Deutsche Dom Berlin (2005)

SIGNS & PRODUCTS
2004-2010

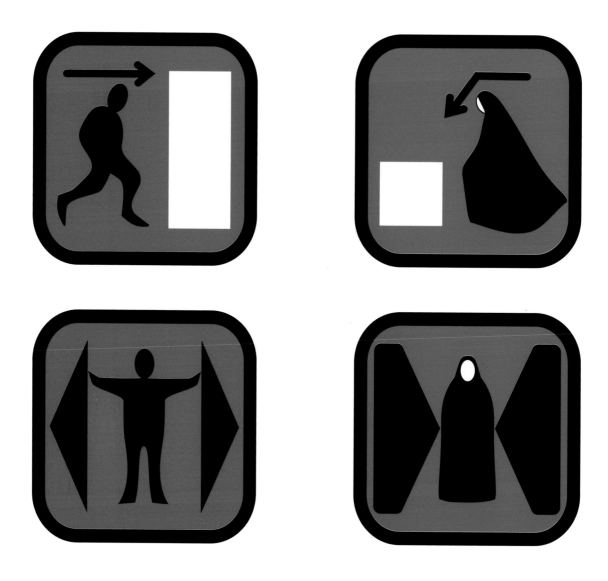

"Signs", series of laminated digital drawings on aluminium, 40cm diameter (2004-2010)

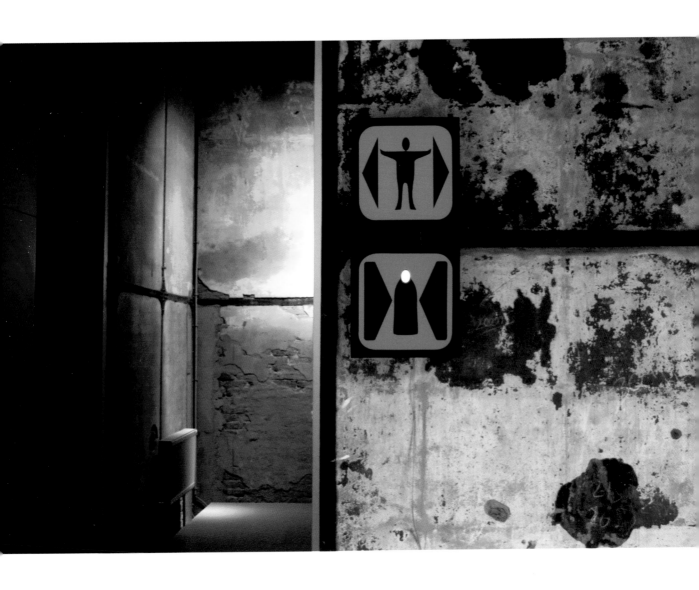

"Signs", installation of light boxes for "Mahrem", Santralistanbul (2008) 93

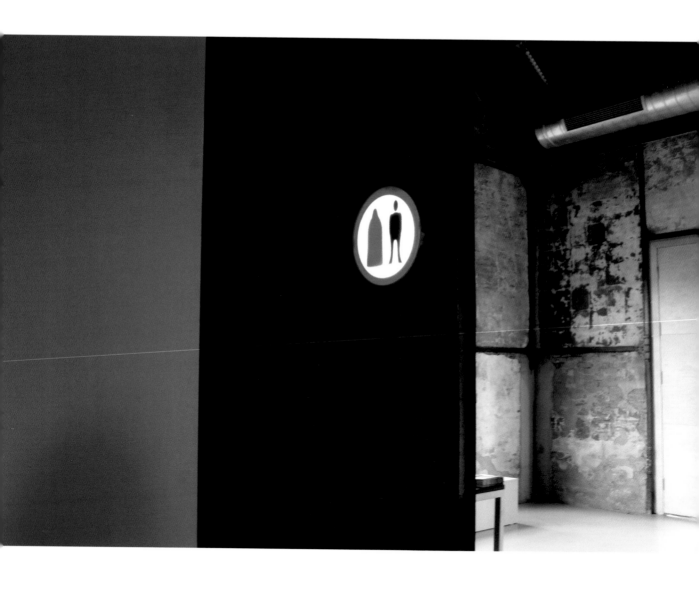

"Signs", installation of light boxes for "Mahrem", Santralistanbul (2008)

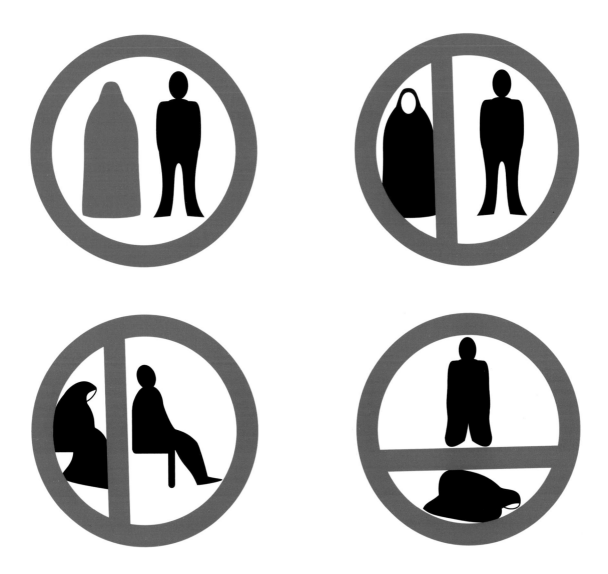

"Signs", series of laminated digital drawings on aluminium, 40cm diameter (2004-2010)

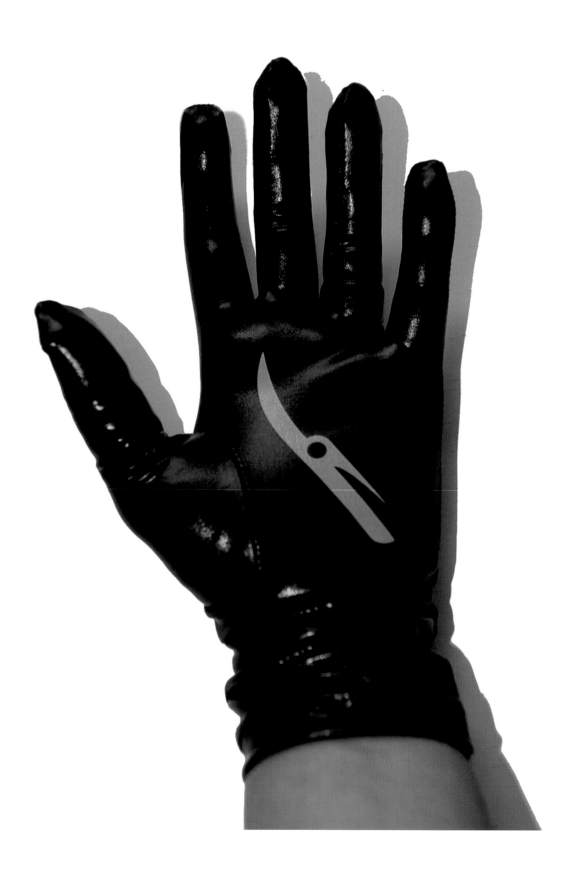

"Black & Pink Collection: Gloves", silkscreen print on elasticated fabric (2007)

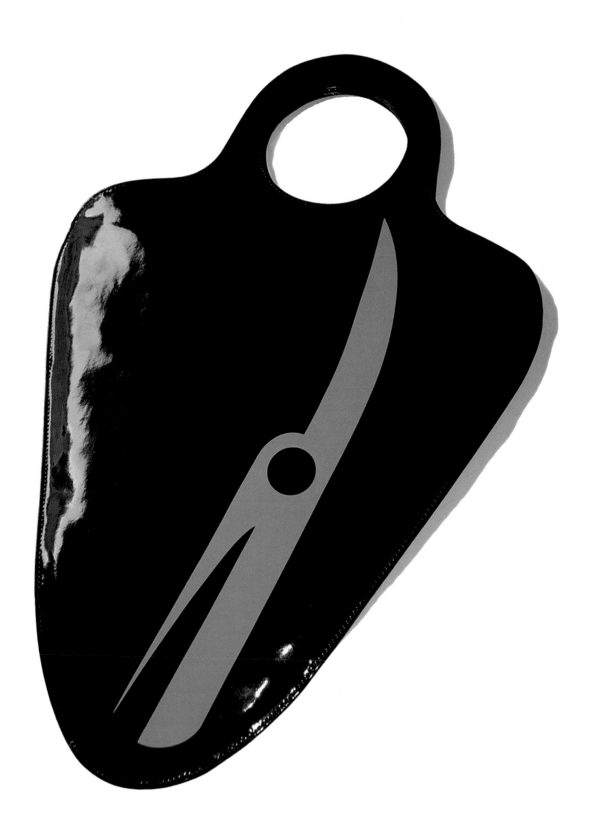

"Black & Pink Collection: Bag", silkscreen print on synthetic leather (2007)

PHOTOGRAPHY
2001-2010

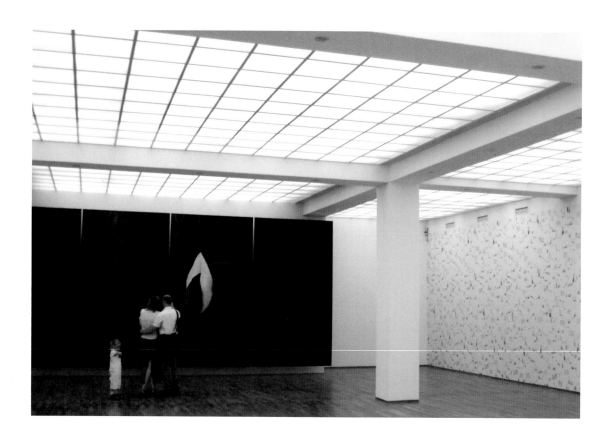

"Friday", digital print on vinyl, 6m x 2m, "A Thousand and One Days", National Gallery Hamburger Bahnhof, Berlin (2003)

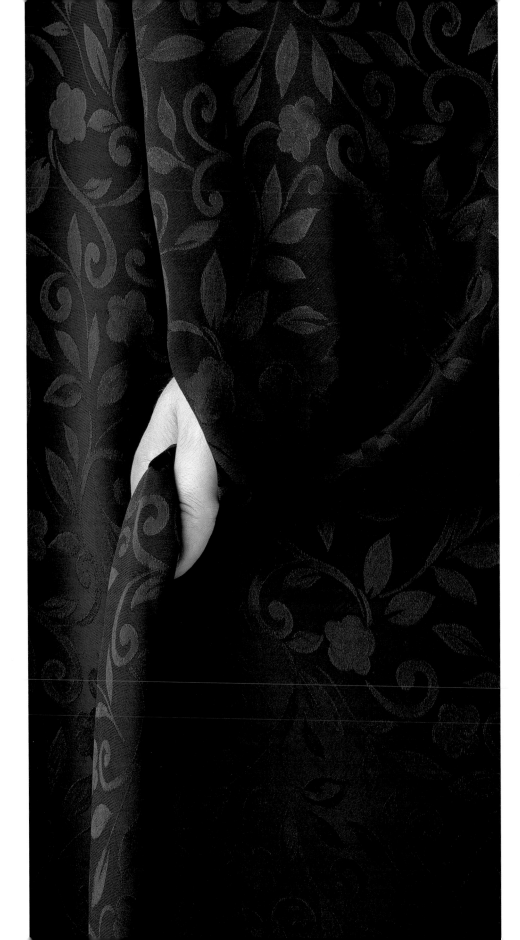

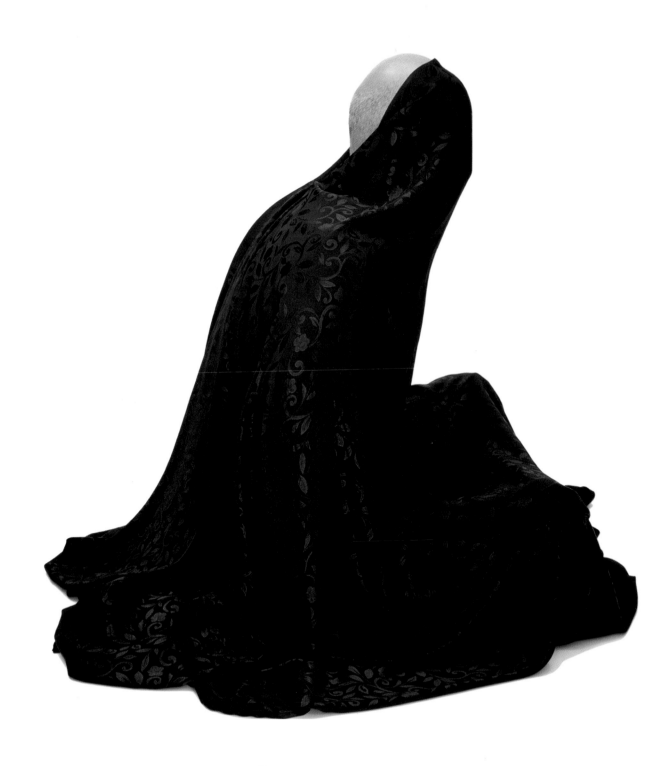

"Blind Spot", series of photographs, digital print on Alu Dibond, 110cm x 150cm (2001-2010)

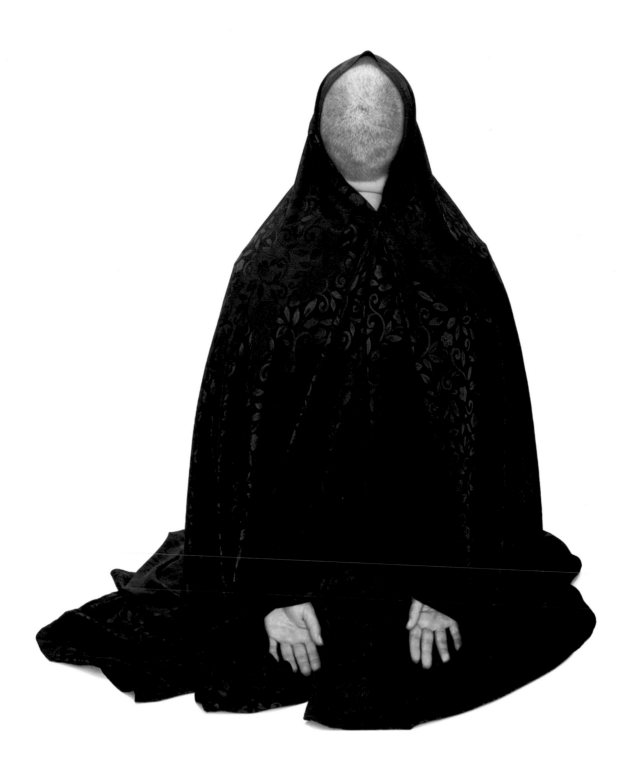

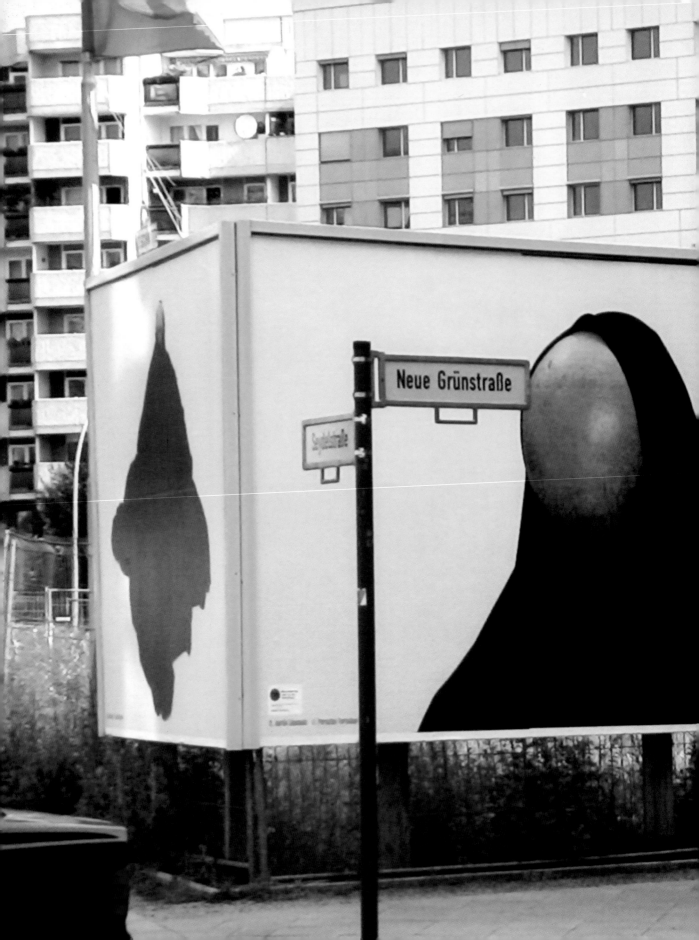

"Blind Spot", billboard installation, Second Berlin Biennale (2001)

"Rorschach: Behnam", digital print on plexiglass, 50cm x 220cm (2008-2010)

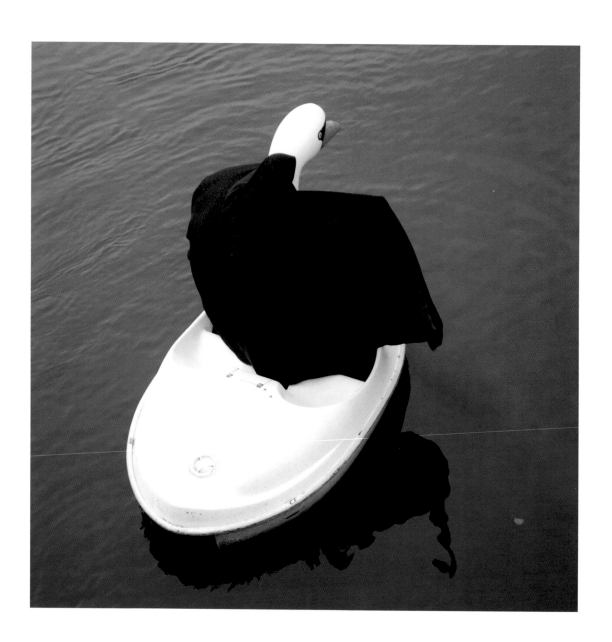

"The Swanrider", series of photographs, digital print on Alu Dibond, 80cm x 80cm (2004-2010)

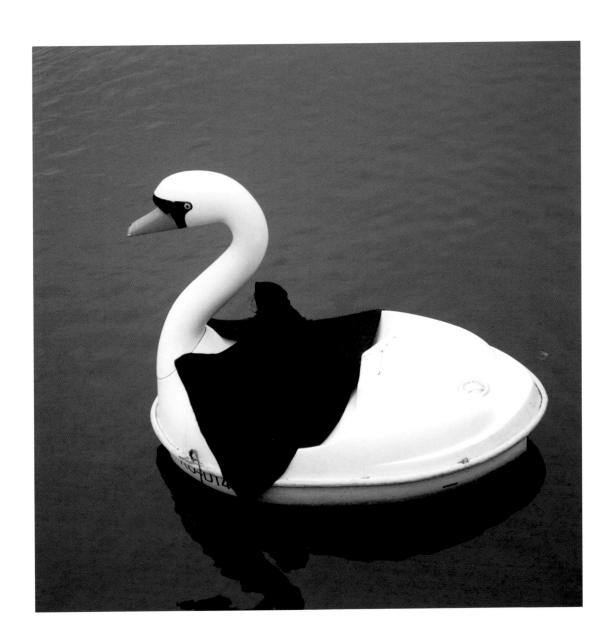

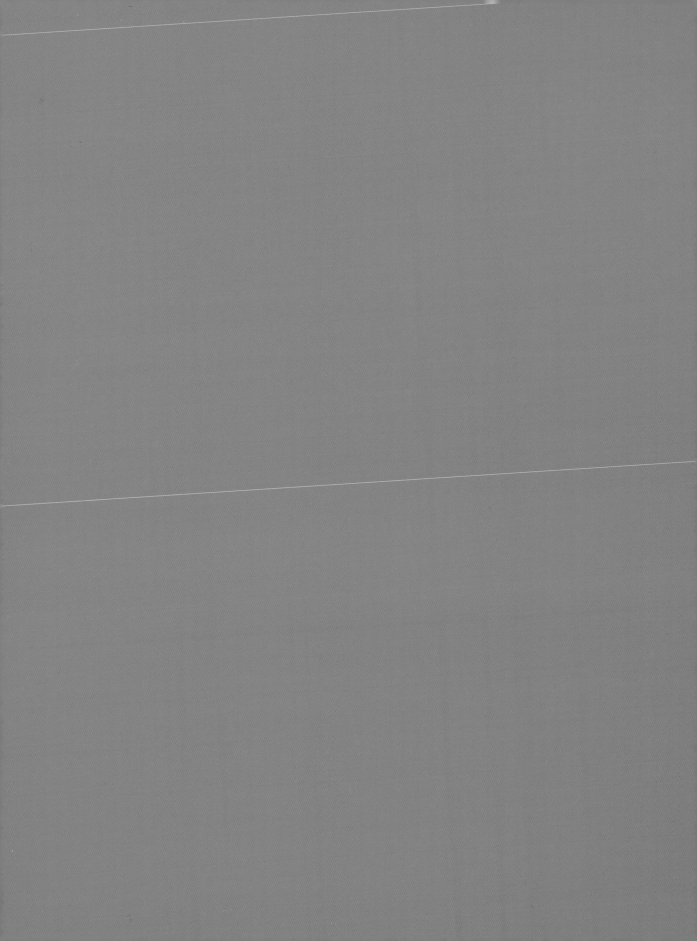

VILLA MASSIMO
2006

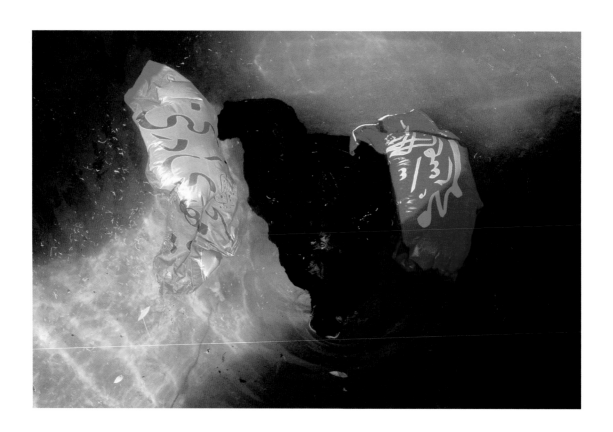

"Villa Massimo – Dolce Vita", images from slide-show projection (2006)

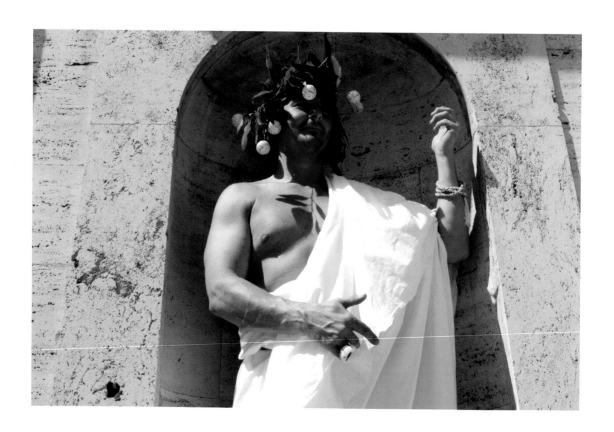

"Villa Massimo – Ping Pong Caesar", images from slide-show projection (2006)

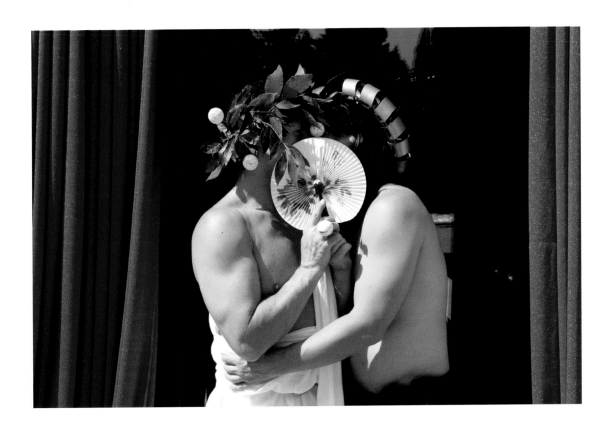

"Villa Massimo – Render Unto Caesar the Things Which are Caesar's", images from slide-show projection (2006)

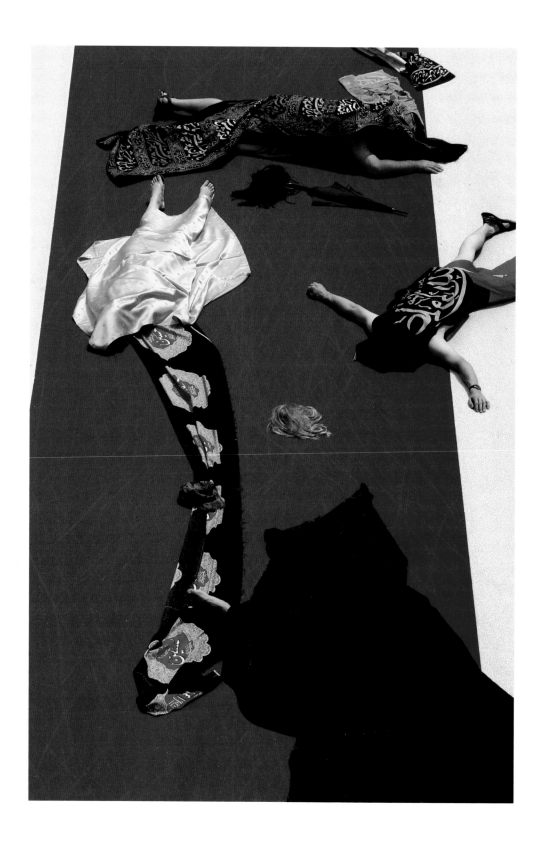

"Villa Massimo – Roman Martyrs", images from slide-show projection (2006)

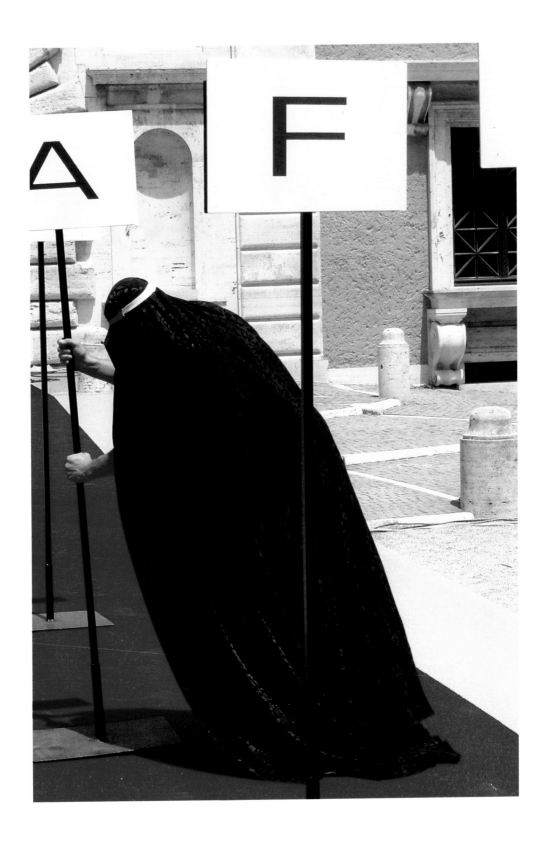

"Villa Massimo – Roman Catwalk", images from slide-show projection (2006)

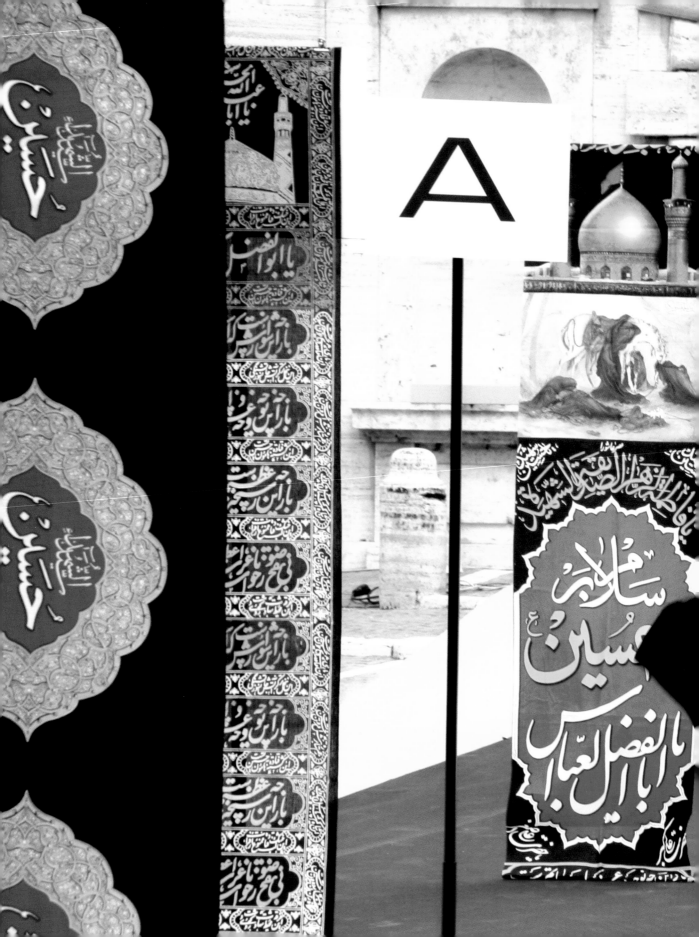

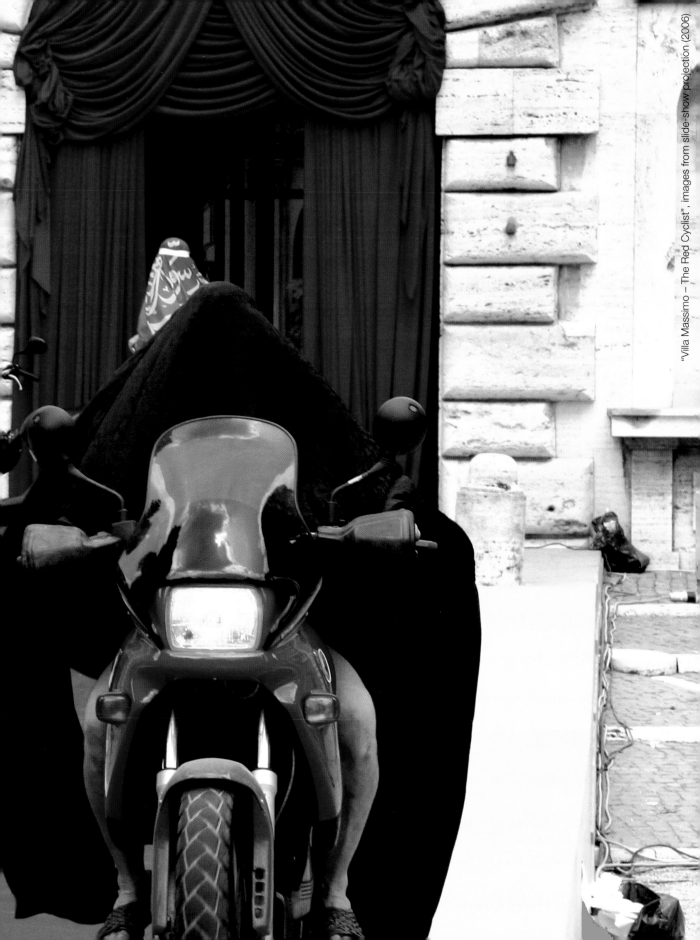

"Villa Massimo – The Red Cyclist", images from slide-show projection (2006)

BIOGRAPHY

Parastou Forouhar was born in 1962 in Tehran, and since 1991 has lived and worked in Germany. She received her BA in Art from the University of Tehran (1990) and her MA from the Hochschule für Gestaltung, Offenbach am Main, Germany (1994).

SOLO SHOWS

2010
"Parastou Forouhar", Rose Issa Projects at Leighton House Museum, London

2009
"Parastou Forouhar", Karin Sachs Gallery, Munich
"Links of Violence", Orgelfabrik, Karlsruhe
"I Surrender", Azad Gallery, Tehran

2008
"Parade", Kunsthalle Vierseithof, Lückenwalde

2007
"Just A Minute", Fondazione Pastificio Cerere, Rome

2005
"Parastou Forouhar", Deutscher Dom, Berlin
"Spielmannszüge" ("Marching Bands"),
Forum of the Dominican Monastery, Frankfurt

2004
"Schuhe ausziehen" ("Take Off Your Shoes"),
Einstein Forum, Potsdam
"Sprache des Ornaments" ("The Language of Ornament"), City Museum Spital, Crailsheim

2003
"Tausendundein Tag" ("A Thousand and One Days"),
National Gallery Hamburger Bahnhof, Berlin

2002
"Parastou Forouhar: Schuhe ausziehen"
("Take Off Your Shoes"), Gallery de Ligt, Frankfurt

2001
"Blind Spot", Stavanger Cultural Centre,
Norway and Schulstrasse 1A, Frankfurt

GROUP SHOWS

2010
"Iran diVerso: Black or White?",
Verso Arte Contemporanea, Turin
"Krieg/Individuum" ("War/Person"),
Ausstellungshalle zeitgenössische Kunst Münster
"Veiled Memoirs", XIV Biennale Donna, Ferrara

2009
"Die Macht Des Ornaments" ("The Power
of Ornament"), Belvedere, Vienna
"Traum und Wirklichkeit" ("Dreams and Reality"),
travelling show: Zentrum Paul Klee, Bern and
BM-Suma Contemporary Art Center, Istanbul
"Rebelle", Museum of Modern Art, Arnhem
"Taswir: Pictorial Mappings of Islam and
Modernity", Martin-Gropius-Bau, Berlin
Incheon Women Artists' Biennale, South Korea
"Iran Inside Out", Chelsea Art Museum, New York

2008
"Mahrem", travelling show: Santralistanbul,
Istanbul and Kunsthalle Wien, Vienna
"Re-Imagining Asia", travelling show:
Haus der Kulturen der Welt, Berlin and
New Art Gallery, Walsall

2007
"Global Feminisms", Brooklyn
Museum, New York
"Retracing Territories",
Kunsthalle Fribourg, Switzerland
"Unfinished", BM-Suma Contemporary
Art Center, Istanbul
"Multispeak I", Witte Zaal, Ghent
"Vote for Women", Kunst Meran, Merano
"Naqsh", Pergamon Museum, Berlin

2006
"Eastern Expressway", Evangelische
Stadtakademie, Frankfurt
"Das Kritische Auge" ("The Critical Eye"),
Neuer Kunstverein Aschaffenburg

"Hannah Arendt Denkraum", former
Jewish Girls' School, Berlin

2005
"Intersections", Jewish Museum of Melbourne
and Jewish Museum of San Francisco

2004
Busan Biennale, South Korea
"Gabriele Münter Price", travelling show:
Martin-Gropius-Bau, Berlin; Frauenmuseum, Bonn
"Entfernte Nähe" ("Far Near Distance"), Haus der
Kulturen der Welt, Berlin
"Die Zehn Gebote" ("The Ten Commandments"),
Deutsches Hygiene-Museum, Dresden
"Triennale of Contemporary Art", Oberschwaben, Weingarten

2003
"M_ARS", New Gallery at Landesmuseum, Graz
"Gæstebud – Feast/Hospitality", Århus, Denmark

2002
"Die Quelle als Inspiration" ("The Source of Inspiration"),
Franckesche Foundation, Halle, East Germany

2001
Second Berlin Biennale, Germany
"Frankfurter Kreuz" ("The Frankfurt Cross"), Schirn
Kunsthalle, Frankfurt
"Wegziehen" ("Migration"), Frauenmuseum, Bonn

PUBLIC COLLECTIONS
Parastou Forouhar's work is in the permanent
collections of The Queensland Art Museum, Queensland;
Belvedere, Vienna; Badisches Landesmuseum, Karlsruhe;
Musem of Modern Art, Frankfurt; and the Deutsche Bank
Art Collection.

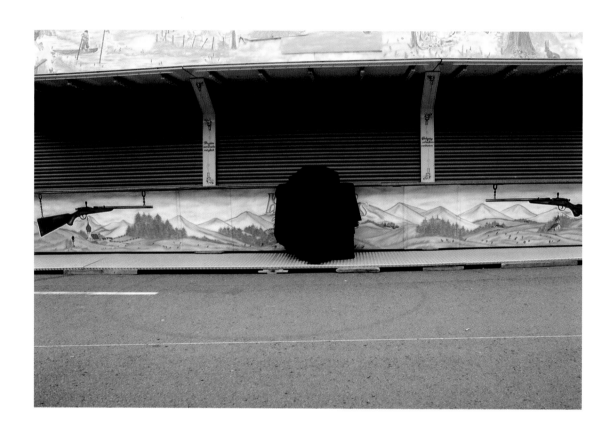

"Shoot", two photographs, digital print on Alu Dibond, 20cm x 30cm (2008)

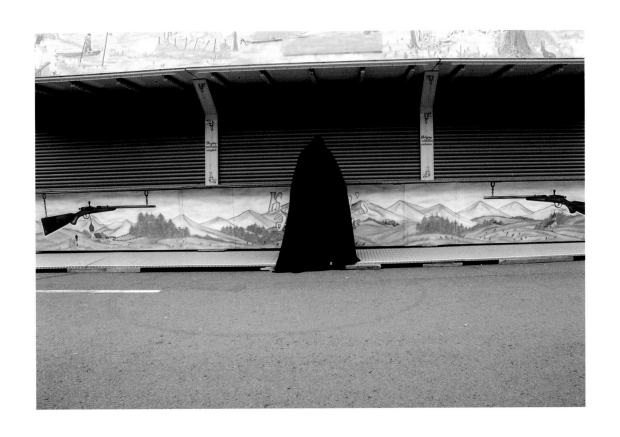

SELECTED BIBLIOGRAPHY

· *Un Plan Simple,* exhibition catalogue
 (Maison Populaire & Edition B42, 2010)
· *Iran diVerso: Black or White?,*
 exhibition catalogue (Verso Editioni, 2010)
· *Memorie Velate*, exhibition catalogue,
 XIV Biennale Donna, Ferrara (2010)
· *Krieg/Individuum*, exhibition catalogue
 (Revolver Verlag, 2010)
· Forouhar, Parastou: "Herr Sheriff und die Revolution"
 in *Feuilleton der FAZ* (18.02.2010)
· *The Power of Ornament,* exhibition catalogue,
 Belvedere (2009)
· Almuth Spiegler: "Pop trifft Islam: Imame wie
 Filmstars" in *Die Presse* (20.01.2009)
· Scherf, Martina: "Schrecklich schoener Schein"
 in *Süddeutsche Zeitung* (30.04.2009)
· Winkelbauer, Andrea: "Aerger im Paradies" in
 Neue Zuericher Zeitung (2.04.2009)
· *Iran Inside Out*, exhibition catalogue,
 Chelsea Art Museum (2009)
· Bloch, Werner: "Das totalitaere Ornament"
 in *Süddeutsche Zeitung* (11.09.2009)
· Thoss, Michael M: "Die Wiederkehr des Ornaments"
 in *DU Kulturmagazin* (02.2009)
· *Taswir – Pictorial Mappings of Islam and
 Modernity,* exhibition catalogue (Nicolaische
 Verlagsbuchhandlung GmbH, 2009)
· Ongha, Hamid: "Barrieren gegen das Gedenken"
 in *Frankfurter Rundschau* (9.12.2009)
· Maier, Andreas: "Sonst sterben sie wieder"
 in *Feuilleton der FAZ* (15.12.2009)
· Regg Cohn, Martin: "Iranians Imprisoned by
 Their History" in *The Star* (15.12.2009)
· Amirpour, Katajun: "Verdaechtiges Gedenken"
 in *Süddeutsche Zeitung* (10.12.2009)
· *Re-Imagining Asia*, exhibition catalogue,
 Haus der Kulturen der Welt (2008)

· Ruthe, Ingeborg: "Morgen-abendlaendische Parade"
 in *Berliner Zeitung* (4.06.2008)
· Hoffmann, Christiane: "Eine Familie im Wiederstand"
 in *Feuilleton der FAZ* (28.12.2008)
· *Iranian Fall*, artist book (Robstolk & Mondrian
 Foundation, 2008)
· *Global Feminisms*, exhibition catalogue
 (Merrell/Brooklyn Museum, 2007)
· *Parastou Forouhar*, exhibition catalogue,
 Deutsche Akademie Rom Villa Massimo (2007)
· *Parastou Forouhar*, exhibition catalogue,
 Altana Kulturstiftung (2007)
· Forouhar, Parastou: "Rays of Light from Planet Iran",
 in *RES Magazin no. 1* (September 2007)
· Karentzos, Alexandra: "Ironische Techniken
 in der Kunst Parastou Forouhar", in *Der Orient,
 Die Fremde – Positionen zeitgenössischer Kunst
 und Literatur* (Transcript Verlag, 2006)
· Forouhar, Parastou: "Unsere Freiheit hinter Gittern",
 in *Feuilleton der FAZ* (08.04.2006)
· Lau, Jörg: "So ein Nichts vertritt unser Land",
 in *Die Zeit* (16.03.2006)
· *Das Kritische Auge*, exhibition catalogue,
 Neuer Kunstverein Aschaffenburg (2006)
· *Mein Iran*, by Ebadi, Shirin (Pendo Verlag, 2006)
· Forouhar, Parastou: in "Hannah Arendt Denkraum",
 exhibition catalogue (2006)
· Ruthe, Ingeburg: "Die erstickende Welt der Muster"
 in *Feuilleton der Berliner Zeitung* (08.03.2005)
· *Spielmannszug*, exhibition catalogue
 (Saarlaendisches Kuenstlerhaus Saarbruecken, 2005)
· *Patterns in Design, Art and Architecture* by Schmidt,
 Petra; Tietenberg, Annette; Wollheim, Ralf (eds.)
 (Birkhäuser Verlag, 2005)
· *Zeit-zonen*, exhibition catalogue, by Hausmann, Brigitte
 & Scheutle, Rudolf [eds.] (Revolver/Verlag, 2005)
· Crüwell, Konstanze: "Daumenkino mit Tausendundein

Tag", in *Feuilleton der FAZ* (02.09.2005)

· *Intersections: Reading the Space*, exhibition
catalogue, Jewish Museum of Australia (2005)

· Graf, Sabine: "Schönes Spiel mit grausamer Realität",
in *Saarbrücker Zeitung* (15.12.2005)

· Schütte, Christoph: "Kaleidoskop der Grausamkeiten",
in *Feuilleton der FAZ* (01.11.2005)

· *The Swanrider*, residency catalogue (Kuenstlerhaus
Schloss Balmoral, 2004)

· *Das Eerinnerte Haus*, exhibition catalogue,
Museum Folkwang (2004)

· *Gabriele Münter Preis 2004*, exhibition
catalogue, Frauen Museum (2004)

· Ruthe, Ingeburg: "Schuhe ausziehen" in
Magazin der Berliner Zeitung, no.113 (15/16.05.2004)

· Thielebein, Marion: "Intime Räume",
in *Neue Deutsche Literatur* (October 2004)

· Busan Biennale, exhibition catalogue (2004)

· Kroetz, Rita: "Zwischen Kunst und Politik",
in *Kommune* (1/2004)

· Tilmann, Christiane: "Interview mit Parastou Forouhar
u. Farhad Moshiri", in *Der Tagesspiegel* (19.03.2004)

· *M_ARS: Kunst und Krieg*, exhibition catalogue,
Ostfildern-Ruit (2003)

· Karentzos, Alexandra: "Bilder und Zeichen"
in *Feministische Studien* (2/2003)

· Görner, Karin & Hentschel, Linda: "Zur Edition"
in *Frauen Kunst Wissenschaft* (Heft 36/ Dez .2003)

· Schütte, Christoph: "Blinder Fleck unter dem
Tschador", in *Feuilleton der FAZ* (10.04.2002)

· Nirumand, Bahman: "Vertuschung statt
Aufklärung", in *Taz* (12.11.2002)

· Hoppe, Ralf: "Aufstand einer Tochter",
in *Der Spiegel* (30.12.2002)

· Larass, Petra: "Die Quelle als Inspiration", in
Franckesche Stiftung (Halle 2002)

· *Tausendundein Tag/A Thousand and One Days* (Walter

König/National Gallery Hamburger Bahnhof, 2003)

· de Bellaigue, Christopher: "Teheraner Schattenspiele"
in *Lettre International* (Heft 4, 2001)

· Amman, Jean Christophe: "Kultur-Kampf:
Parastou Forouhar", in *Kunstzeitung* (March 2001)

· de Ligt, Natalie: "Parastou Forouhar",
in *Frankfurter Kreuz*, exhibition catalogue, Schirn
Kunsthalle, Ostfildern-Ruit (Hatje Cantz-Verlag, 2001)

· Salden, Dr. Hubert: "Parastou Forouhar" in
Second Berlin Biennale, exhibition catalogue
(Hatje Cantz-Verlag, 2001)

· Baer-Bogenschütz, D: "Auferstehung des Ichs",
in *Berliner Morgenpost* (17.04.2001)

· Vogel, Sabine: "Der Riss im Schador",
in *Feuilleton der Berliner Zeitung* (09/10.06.2001)

· *Wegziehen*, exhibition catalogue, by Forouhar,
Parastou (Frauenmuseum Bonn, 2001)

· Forouhar, Parastou: "Die Chiffre Taliban",
in *Feuilleton der FAZ* (18.12.2001)

· Hashemi, Kazem: "Interview mit Parastou
Forouhar", in *Ai-Journal* (Heft 5, Mai 2001)

· Hoffmann, Andrea Claudia: "Wer hat meine
Eltern getötet", in *Allegra* (No. 2, 2000)
and *Emma* (June-August 2000)

· Özdemir, Cem: "Heimat ist ein Haus voller
Pingpongbälle", in *ART* (June 2000)

· Kiehl, Phyllis: "Parastou Forouhar", in *Heimat Kunst*,
exhibition catalogue, Haus der Kulturen der Welt (2000)

· Forouhar, Parastou: "Persönliche Chronik der
Ermordung unserer Eltern", in *The Metronome,
Or Backwards Translation*" (No. 4-5-6, 1999),
by Clémentine Deliss, ed. (Metronome Press)

· Hoffmann, Andrea Claudia: "Interview mit Parastou
Forouhar" in *Frankfurter Rundschau* (14.06.1999)

· Forouhar, Parastou: "Die Weiber Wirtschaft" in *Frauen
in Kunst und Kultur: Dokumentation der Anhörung*
(17 Mai 1999), Magistrat der Stadt Frankfurt am Main